HAREFIELD

THROUGH TIME

Geoffrey Hewlett

AMBERLEY

About the Author

The author lives in the suburbs of north-west London and until his recent retirement worked for forty years as a town planner in local government. His recent output includes books on the history of Kingsbury, the Welsh Harp Reservoir and Stanmore. Drawing on his own knowledge and the experience of many others who have had access to the rich archival resource that Harefield, English Heritage, the Royal London Hospital Archive and Museums Service and Hillingdon Council maintains, the author is particularly grateful for the access to and use of Harefield's archives, without whose consent such a publication would not be possible.

In addition, he would like to express his thanks to John Parkinson for his dedication and photographic skills; to his wife, Susan, for her photographic and artistic skills and transportation provided; and to Revd Martin Davies, the Vicar of St Mary's church and a man of many skills, who engaged the author in this project in the first place.

First published 2013

Amberley Publishing
The Hill, Stroud, Gloucestershire, GL5 4EP
www.amberley-books.com

Copyright © Geoffrey Hewlett, 2013

The right of Geoffrey Hewlett to be identified as the Author of this work has been asserted in accordance with the Copyrights, Designs and Patents Act 1988.

ISBN 978 1 4456 0727 6

British Library Cataloguing in Publication Data.
A catalogue record for this book is available from the British Library.

Typesetting by Amberley Publishing.
Printed in Great Britain.

Introduction

The village of Harefield lies on the edge of Greater London (and is, in fact, almost the last village left within it) in the Borough of Hillingdon, on a plateau above the Colne Valley and between Denham, Northwood and Ruislip. The village is a mere 17 miles (27 km) from Charing Cross.

The earliest people in the area can be traced back as far as 400,000 BC and more sophisticated flint tools appear at Denham and Harefield from around 200,000 BC, on gravel islands on the floor of the valley. The early stages of the area's development are covered elsewhere in studies of the river basin, but let it suffice to say that early man recognised the area's character and potential and settled here. For the origin of today's village we need to look to late Saxon times, when it has been suggested that, given the outlines of a moat that are still discernible, an early form of mound or fortification existed here.

The Domesday Book in 1086 records the place as *Herefelle*, using the Anglo-Saxon words for 'the field' of the '[Danish] Army' or 'people'. The second 'a' in *hara*, the word for a hare, does not appear until the year 1223, so the word for army or people remains the likely translation. This is also supported by the ownership of the estate, pre-Domesday, by Countess Goda, the sister of the Saxon King, Edward the Confessor, during whose reign (and for some 200 years beforehand) Danish invasions and settlement had taken place. Saxon records from AD 893 relate to a host of Danes taking refuge on an island in the Colne after escaping from King Alfred's army. Following the Norman Conquest, the estate passed to Richard FitzGilbert, who took the main manor of Harefield, leaving the smaller units of Brackenbury and Moorhall.

Unlike many parts of London, Harefield has maintained its relative isolation and village character. The River Colne has cut its way into the landscape along its western edge and the valley dictated the route of the canal and roads. Harefield's ancient church lies on lower ground at the southern flank, not on the hilltop where many, but not all, of the grander buildings stood. The manor house next door may well have had two sites where it grew at different times.

The village green may have been at the heart of Harefield, but it was not recognised for recreational use until 1813. There was no railway to run along the valley floor, although a line had been proposed between Uxbridge and Rickmansworth, which reached the stage of an Act of Parliament. The location of industrial activity along the valley exploited the advantages of such a location, but industrial activity predated the canal by a considerable period, with a paper mill in 1674 and a corn mill before that. The village grew up the hill

Habitat creation and retention. (*Courtesy of the Colne Valley Park*)

from the sixteenth century, but the influence of the canal on the growth of the built up area was minimal. Settlement growth was slow and reflected limited public transport, with only a few bus routes provided to Uxbridge.

Harefield's lack of good public transport meant that suburbanisation or growth into a dormitory town or a suburb of London did not occur. Village life and its charm have not followed the suburbanising trend, and the following account looks at the way this came about. Despite the threats of new buildings, existing local character has been maintained. In studying the village, the approach adopted has been to subdivide the area into five geographical districts, reflecting the number of routes leading out from or into the centre. Each walk is typically between 1.75 km and 3.25 km in length, but can be adapted to make its form circular. The second walk can also be extended to explore the Dogs' Trust, and all of the walks can be broken off at any point should the weather turn inclement.

The King's Arms public house, which dates back to the fifteenth century, stands on the north-west side of the crossroads. By the village pond is a memorial to those who died in the First World War. Further memorials can be seen in St Mary's church and in the Anzac Cemetery beyond the church. The Anzac Cemetery pays tribute to those Australians who fell at Gallipoli nearly a century ago. Harefield Hospital stands on the site of Harefield Park, which gave Park Lane its name. The road leads down to canalside premises, which began as mills before the arrival of the canals. The number of estates based on Georgian manor houses and earlier imposing sixteenth-century mansions reflect the area's long history, of which *Harefield Through Time* still has its own individual story to tell.

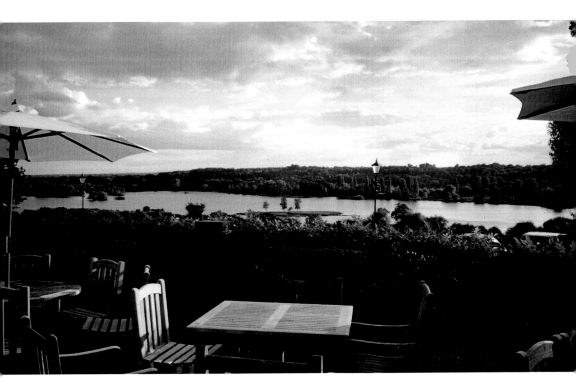

The Old Orchard
A view over the Colne Valley from the patio of the Old Orchard public house, Harefield. (*Image courtesy of Brunning & Price*)

Establishing Norman Origins

The information available on one of Harefield's important families provides the opportunity to follow its fortunes through the good and bad times enjoyed by the lords of the manor, from their family names and the land that they owned in the Domesday Book of 1086. From tombstones to brasses in the parish church of St Mary, it is possible to trace the lords of the manor in direct descent from those who came over with King William at the time of the Conquest. A direct consequence of the invasion was the substantial elimination of the English aristocracy. As landowners, the Normans dominated the scene, politically and economically, and their buildings reflected their strength. As King William dispossessed English landowners, he then conferred their properties on his continental supporters. On spiritual matters, closer ties were achieved by appointing Lanfranc as Archbishop of Canterbury in 1070–89. Harefield was split, leaving the main manor with two smaller sub-manors of Brackenbury and Moor Hall. By the 1170s, the English were living side by side with the Normans and intermarrying. The introduction of this new stratum meant that in 1235, Harefield passed from Richard FitzGilbert, who was the son of the Norman Count Gilbert of Brionne, to the Batchworths of Hertford. Batchworth Heath, on the road to Rickmansworth, was named after them. The manor remained with the Batchworths until 1315, when Richard of Batchworth sold it to Simon Swanland. Simon held the manor until at least 1333. On Simon's death and that of his son, William, the latter's daughter married

5

John Newdigate. Harefield and North Mimms manors were then held by Sir John's grandson and the Newdigates held the manor until 1586, when it was exchanged for Arbury in Warwickshire.

In 1601, Harefield Manor was sold to the trustees of Alice, widow of the Earl of Derby and the daughter of Sir John Spencer of Althorp. The Dowager Countess of Derby lived at Harefield until her death in 1636/37, when the manor passed by marriage to her grandson, George Pitt. It was bought back from him in 1675 by Richard Newdigate. By 1760, the family had chosen Arbury as their seat, and a new house was built by Richard in 1786 as somewhere for him to stay when visiting his parish. By 1818/19, this was known as Harefield Lodge and was occupied by Charles Parker, who had assumed the name of Charles Newdigate-Newdegate on his succession to the family estates. Family trees and inscriptions within the church provide a unique record of the active involvement of the Newdigates in the life of the local community. It is fitting that the oldest brass memorial in the church should mark the resting place of William's wife, Edith, and, but for a gap of less than 200 years, almost tells the complete story. The Edith Brass, dating from 444, is shown below.

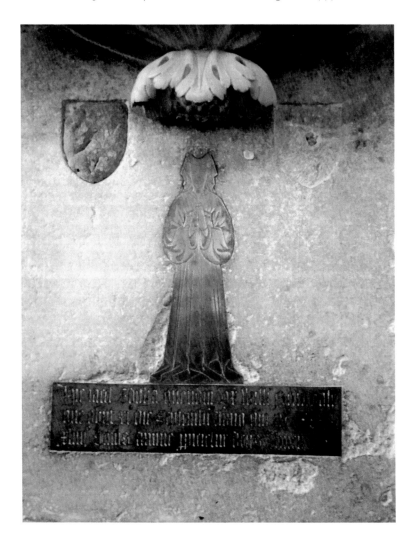

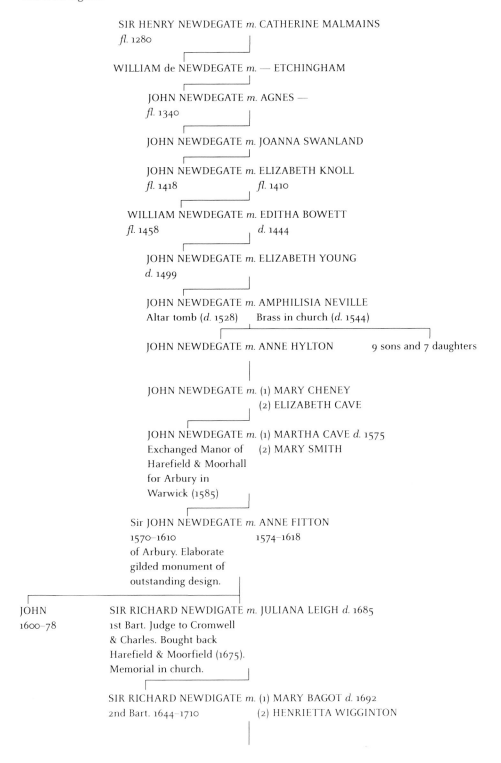

SIR HENRY NEWDEGATE *m.* CATHERINE MALMAINS
fl. 1280

WILLIAM de NEWDEGATE *m.* — ETCHINGHAM

JOHN NEWDEGATE *m.* AGNES —
fl. 1340

JOHN NEWDEGATE *m.* JOANNA SWANLAND

JOHN NEWDEGATE *m.* ELIZABETH KNOLL
fl. 1418 *fl.* 1410

WILLIAM NEWDEGATE *m.* EDITHA BOWETT
fl. 1458 *d.* 1444

JOHN NEWDEGATE *m.* ELIZABETH YOUNG
d. 1499

JOHN NEWDEGATE *m.* AMPHILISIA NEVILLE
Altar tomb (*d.* 1528) Brass in church (*d.* 1544)

JOHN NEWDEGATE *m.* ANNE HYLTON 9 sons and 7 daughters

JOHN NEWDEGATE *m.* (1) MARY CHENEY
 (2) ELIZABETH CAVE

JOHN NEWDEGATE *m.* (1) MARTHA CAVE *d.* 1575
Exchanged Manor of (2) MARY SMITH
Harefield & Moorhall
for Arbury in
Warwick (1585)

Sir JOHN NEWDEGATE *m.* ANNE FITTON
1570–1610 1574–1618
of Arbury. Elaborate
gilded monument of
outstanding design.

JOHN SIR RICHARD NEWDEGATE *m.* JULIANA LEIGH *d.* 1685
1600–78 1st Bart. Judge to Cromwell
 & Charles. Bought back
 Harefield & Moorfield (1675).
 Memorial in church.

SIR RICHARD NEWDIGATE *m.* (1) MARY BAGOT *d.* 1692
2nd Bart. 1644–1710 (2) HENRIETTA WIGGINTON

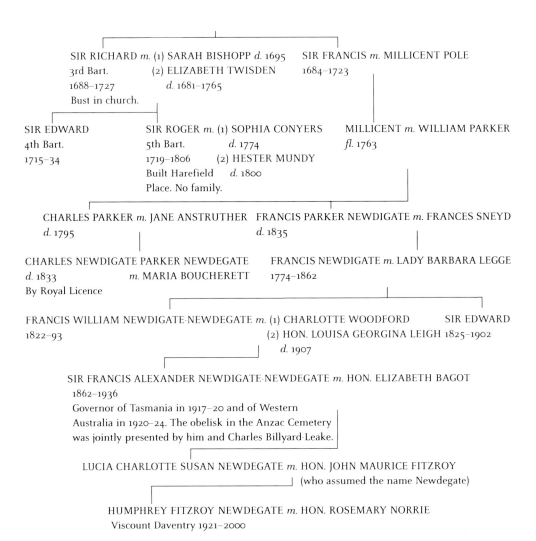

SIR RICHARD *m.* (1) SARAH BISHOPP *d.* 1695 SIR FRANCIS *m.* MILLICENT POLE
3rd Bart. (2) ELIZABETH TWISDEN 1684–1723
1688–1727 *d.* 1681–1765
Bust in church.

SIR EDWARD SIR ROGER *m.* (1) SOPHIA CONYERS MILLICENT *m.* WILLIAM PARKER
4th Bart. 5th Bart. *d.* 1774 *fl.* 1763
1715–34 1719–1806 (2) HESTER MUNDY
 Built Harefield *d.* 1800
 Place. No family.

CHARLES PARKER *m.* JANE ANSTRUTHER FRANCIS PARKER NEWDIGATE *m.* FRANCES SNEYD
d. 1795 *d.* 1835

CHARLES NEWDIGATE PARKER NEWDEGATE FRANCIS NEWDIGATE *m.* LADY BARBARA LEGGE
d. 1833 *m.* MARIA BOUCHERETT 1774–1862
By Royal Licence

FRANCIS WILLIAM NEWDIGATE-NEWDEGATE *m.* (1) CHARLOTTE WOODFORD SIR EDWARD
1822–93 (2) HON. LOUISA GEORGINA LEIGH 1825–1902
 d. 1907

SIR FRANCIS ALEXANDER NEWDIGATE-NEWDEGATE *m.* HON. ELIZABETH BAGOT
1862–1936
Governor of Tasmania in 1917–20 and of Western
Australia in 1920–24. The obelisk in the Anzac Cemetery
was jointly presented by him and Charles Billyard-Leake.

LUCIA CHARLOTTE SUSAN NEWDEGATE *m.* HON. JOHN MAURICE FITZROY
 (who assumed the name Newdegate)

HUMPHREY FITZROY NEWDEGATE *m.* HON. ROSEMARY NORRIE
Viscount Daventry 1921–2000

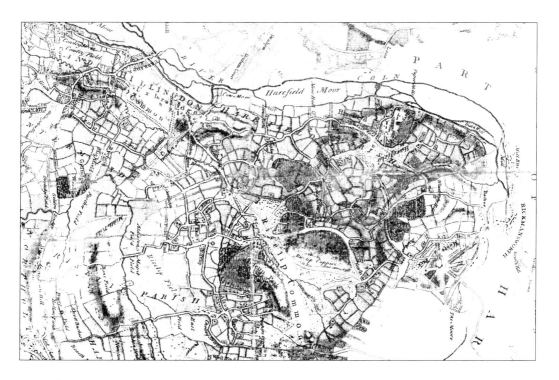

The Changing Shape of the Village

Three maps, including the above map by John Rocque, show Harefield at different stages of development. The roads meet at the centre by the green, but this was a large area of open common land at the centre prior to the Enclosure Award of 1813. The fifteenth-century Kings Arms was accompanied by a smithy on Victorian maps; these roads survive today and are still traceable.

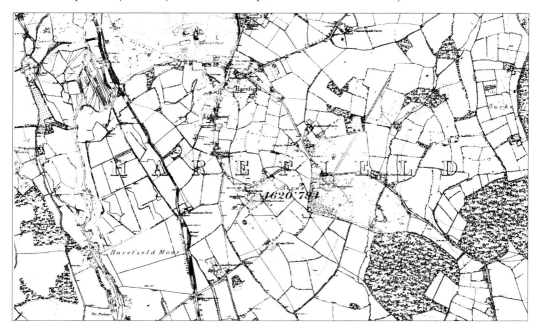

Reproduced from the 1868 edition of the Ordnance Survey, 25 inches to 1 mile map of Middlesex.

The Changing Shape of the Village

By 1868, Gunnings Farm on Park Lane had become Colney's Farm, having been bought and rebuilt by Cooke in 1752. In 1900, fish ponds were still visible in the grounds of Harefield Park.

Nonconformist chapels appeared in the nineteenth century on the Rickmansworth Road and membership grew rapidly. The Baptist chapel was built in 1834 and therefore appears in the tithe map of 1845. The Methodist chapel appeared in 1864 and was closed and demolished in 1896. From 1896, industry in the form of additional mills had expanded along the Colne Valley.

In 1900, Harefield Mill lay to the west and Shepherd's Hill to the east. Later still, the road to Shepherd's Hill Farm, once Tosses Lane, became Northwood Road. The post office and nearby buildings are probably of late-Victorian date, judging from their brick. Hither too came a guide post and yet, for all that, there is surprisingly little change. By 1916, Harefield was still a village in the fields.

The map below has used a base of wartime Harefield in 1916 and was later updated in 1935 and then by the map maker on an almost year-by-year basis in the 1950s. Harefield's notable time of expansion was to be in the 1950s and 1960s around the core of the village. This will also be seen in the north and south of the village, and the information provided by the map is helpful in confirming what residents remember.

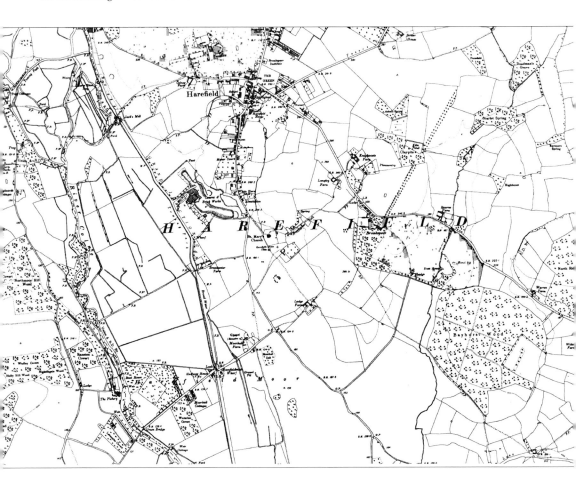

Reproduced from the 1920 edition of the Ordnance Survey, 25 inches to 1 mile map of Middlesex.

Infrastructure for Expansion

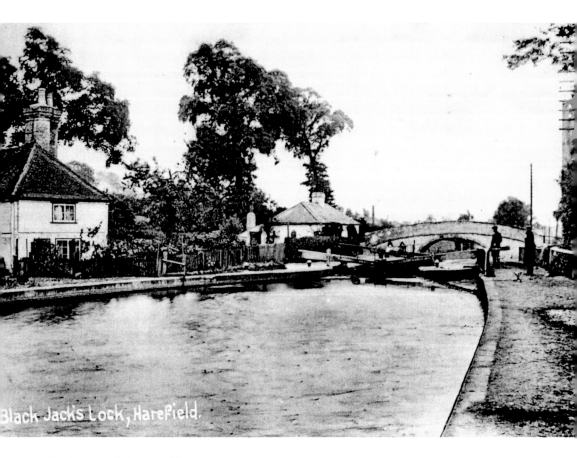

Black Jack's Lock, Harefield.

The Impact of the Canal System

The 4,000-mile network of canals in Britain was the backbone of the Industrial Revolution. The Grand Junction was authorised by Parliament in 1793 and the section of the canal between Brentford and Uxbridge was opened in November 1794. The Grand Junction Canal Company started buying land in Harefield around 1795, and this enabled the canal to be opened from Brentford to Hemel Hempstead via Harefield in 1797. A lock-keeper was appointed at the copper mills in 1798 on a wage of 75p a week. From the first half of the 1800s the canal stimulated local industries, such as sand and gravel extraction, lime, bricks, timber and agricultural produce in addition to the copper works. Canal trade was brisk in the 1830s and lock-keepers were given an allowance for candles while on night duty. In each week of 1832, London-bound traffic included over 100 non-stop boats (known as flies) drawn by relays of horses and crewed by four men travelling through the night. The number of workmen employed locally increased correspondingly, with census returns including carters and loaders. Sir George Cooke had opened up chalk pits by 1802, and lime pits and cottages in Summerhouse Lane were being let in the 1890s. Then, in time, the same means of transport was used to fill in the lime pits that had been created. Chalk and lime were major exports from Harefield until the inter-war years and traffic continued to decline, only to be superseded by pleasure craft.

The Enclosure Acts

There was a fundamental change in village life as it moved from the eighteenth century into the nineteenth century, necessitated by the organisation of the enclosure of common land. The Enclosure Act for Harefield was submitted in 1811 and the award and map were completed in 1813. Enclosure was the process by which land that may have previously been held communally passed into private ownership, thus enabling it to be divided into fields using enclosing fences, hedges or walls.

The Act for Harefield was a reflection of the conservation of the rural society and the response to the Act of 1801, which encouraged consolidation of enclosure nationally to help increase food production during the French Wars. The main beneficiaries were the gentry and yeoman farmers, who were able to develop their estates while smallholders at best gained small portions of land and lost their rights to common land, which was enclosed. Large areas of moorland lay in the Colne floodplain, and the first purpose of the Enclosure Act was to enclose the remaining common land. The second was to set in train a series of land exchanges between the major landowners, and thirdly to organise roads and footpaths in the parish, in particular re-routing them in the neighbourhood of Harvil and Moorhall Roads. Lastly, some land was identified for public use, including a village green for cricket. The plan was produced by the surveyor, James Trumper, and drawn at 6 inches to 1 mile.

Road Links

Even today, Harefield is comparatively isolated, just as it was in the nineteenth century. It was 4 miles from the main London–Oxford Road in the days when it ran through Uxbridge. The Enclosure Act of 1813 set out which roads and footpaths were to be maintained at the public expense. There was one road into and out of the village, along with periodic floods and tales of people being stranded. There had been little public transport on the roads until buses brought some measure of improvement. People working outside the area in the 1920s and 1930s used a bicycle. Those who used the National Bus Service to Watford may have got more than they bargained for – buses that got stuck on the hills required the passengers to get out and push.

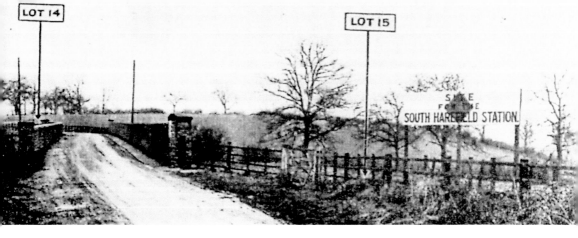

Rail

The character of the village would have been quite different had the main line railway come any closer. There had been numerous Acts of Parliament since 1859 with the objective of linking Uxbridge and Watford but all had failed. However in 1899, the Great Western and Great Central Railways formed a Joint Committee to link their lines with the London termini. In 1906, the companies were asked to make a halt or provide a motor bus service from Harefield to Denham. Harefield Halt and a mileage siding were opened on 24 September 1928, west of the road bridge on which Harvil Road crosses the railway. The adjoining landowner, George Rose, guaranteed an income from the line for three years but then his money ran out. For the London Underground connection, Rose proposed using the earlier rails and developing the land he owned either side of the track. The Central Line would be extended beyond West Ruislip to Denham, with an intermediate station at 'Harefield Road'. The line was intended to stimulate housing but the county council had concerns about the loss of countryside under the 1938 Green Belt Act. Despite financial problems, Rose tried renaming it as 'South Harefield Halt' in May 1929. It closed on 1 October 1931 with the goods yard following in 1952. It was the last main line railway built in this country.

High Speed Solutions

Stimulating the economy, an issue currently galvanising residents into action, is what lies behind the planned fast rail link (High Speed 2) from London (Euston) to the English Midlands and the North, which is intended to boost the regions and rebalance the economy. One proposed route for the entry into London runs through the Colne Valley. The cost of this controversial part of the present government's transportation policy is likely to be in the region of £32 billion, but it has raised a debate that villagers may well have had eighty-five years ago and are having again. Do residents want Harefield to be a suburb of Greater London or to remain as a village with its own character? With the destruction of the countryside proposed in 1928, residents very nearly lived somewhere totally different.

The Suburb that Never Was

In the 1920s and 1930s, Harefield was still not receiving the kind of investment in roads and public transport that was taking place elsewhere in London. This restricted accessibility, which in turn affected population growth and its rate of expansion. Indeed, Harefield was to remain a village for a lot longer, which residents might argue was not a bad thing. In October 1928, it was proposed to develop the 700 acres of the Harefield Place Estate into a residential suburb, served by a church, hotel, shopping centre and station, which had opened during the previous month.

HAREFIELD PLACE ESTATE

The
Most Charming
Estate

Within half-an-hour's journey of London.

BEAUTIFUL WOODLANDS
— and —
LOVELY VIEWS.

MAINLY GRAVEL AND SAND SOIL.
HIGH AND DRY.

*MAIN WATER — GAS — ELECTRIC LIGHT
and SEWERAGE SYSTEM.*

THE HOME FARM.

THE STATION
(Harefield G.W. & G.C. Railway)

IS NOW OPEN
— AND —

40 TRAINS DAILY Run
To and From

PADDINGTON or MARYLEBONE
In **21** to **30** minutes.

FAST SERVICE AND
COMFORTABLE TRAVELLING

THE BEST INVESTMENT IN MIDDLESEX.

HOUSE ON THE ESTATE
(Erected by Harefield Place Estates, Ltd.)

BUY
LAND
AT
Harefield
Place
FOR
RAPID
APPRECIATION
IN VALUE.

HOUSE ON THE ESTATE
(Erected by Harefield Place Estates, Ltd.)

Full particulars from the Estate Office, HAREFIELD PLACE, near Uxbridge.

Phone: UXBRIDGE 347.

NO OVERCROWDING.

About **400 Acres** are ripe for immediate development in 3 Sections :—

1.—Houses and Bungalows from **£750** to **£1,000**
2.—Important Shopping Centre surrounding the Station.
3.—The Park and adjoining the Golf Course — High - class Residences from **£1,400** to **£3,000**

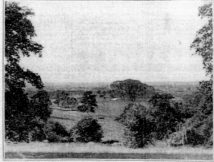

LOOKING OVER PROPOSED GOLF COURSE.

OVER 130 ACRES
are reserved for
a Full Length
18 Hole GOLF COURSE
AND FOR
TENNIS COURTS,
BOWLING GREENS,
Etc., Etc.,
For the Pleasure of Residents.

DO NOT DELAY.
Apply to Estate Office,
Harefield Place, near Uxbridge.

(*Image courtesy of the* Uxbridge Gazette)

Harefield Timeline Over 250 Years (1763–2013)

1765–1809	Count Bruhl (Saxon envoy to England) in residence at Harefield House; studies solar eclipse September 1793.
1782	Copper works commence on site, replacing paper milling.
1786	Harefield Place rebuilt and opened as Harefield Lodge.
1792	Canal system including Grand Junction proposed.
1793	Partial solar eclipse in September; tracked by Ramsden telescope; Ramsden theodolite later used in first Ordnance Survey.
1797	Construction in Harefield; Grand Junction Canal opened.
1799	Extensive development of mills in Colne Valley; thirteen mills in Uxbridge area alone.
1801	First national census.
1801–10	First 1-inch Ordnance Survey available in England.
1806	Death of Sir Roger Newdigate, 5th bart.
1809–14	John Penrose junior minister and curate at Harefield. Both he and his wife were authors.
1811	Enclosure Act.
1813	Issue of enclosure award 'legitimises' use of village green.
c. 1813	Lime and chalk extraction begins in Colne Valley.
1827	Trumper's dog case.
1833	Charles Parker changed his surname to Newdigate-Newdegate to inherit estates.
1837	Accession of Queen Victoria.
1851	Great Exhibition held at Hyde Park; increases awareness of Empire and skills of Paxton.
1863–68	First football club in Harefield founded.
1864	Robert Barnes funds new Memorial Hall.
1870	Copper mills reopened as paper mills; Education Act 1870.
1871	Record of cricket match played in Harefield.
1870	Forster's Education Act set the framework for introducing compulsory education to all those aged between five and twelve years. Infant school held here until 1907.
1880	Opening of Metropolitan Railway: to Harrow (1880); to Rickmansworth (1887).
1882	Asbestos manufacture started.
1886	Cement works open.
1888	Libretto of *The Yeoman of the Guard* written by W. S. Gilbert at Breakspear House.
1889	Wells drilled by Uxbridge Valley Water Company.
1901	Death of Queen Victoria.
1904	Metropolitan Railway opened to Uxbridge.
1910/11	Death of King Edward VII/1911 Coronation of King George V.
1914	Outbreak of First World War and Denham Aerodrome opened.
1915	Survivors of Gallipoli arrive in June; Opening of Australian Military Hospital at Harefield Park.
1918	First memorial service held in April.
1920	Gravel extraction from Colne Valley for Wembley Stadium.
1921	Commonwealth War Graves Commission agrees end of war as at 31 August 1921.

1921	Cemetery formally laid out; 111 men interred and one woman, who died in 1918.
1921/22	First bus service in Harefield.
1922	Closure of Anzac Cemetery to further burials.
1925	Manorial rights cease.
1928	First train service opened to South Harefield Halt (closed 1931).
1937	149-bed hospital opened in Harefield on 7 October by Duke of Gloucester.
1938	Green Belt Act.
1951	Library in Harefield.
1952	Queen Elizabeth II ascends to the throne.
1967	Colne Valley Regional Park opened.
1983	World's first heart and lung transplant carried out at Harefield by Sir Magdi Yacoub.
1990	Harefield recognised as world's leading heart transplant centre.
2000	Millennium celebrations.
2005	Harefield Academy opened in September.
2012	Longest living Harefield heart transplant patient, John McCafferty, celebrates thirty years.
2012	Jubilee celebrations.
2012	Olympic Games.

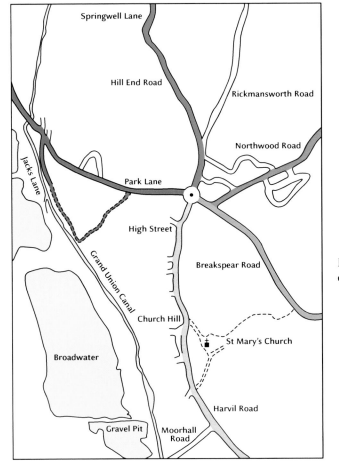

Map of the walks described in the book.

The Five Roads to Harefield
A Walk Through History

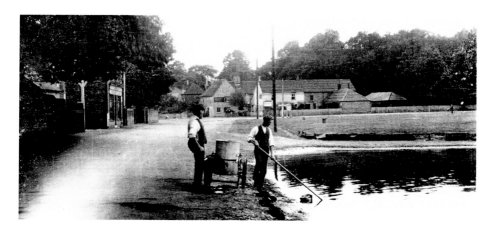

Exploring the Village: Making a Start

In the course of the last eighty years, Harefield has managed to retain its village identity. It has not been absorbed into London's suburbia, as have many of the capital's villages and a particular appreciation is required in order to understand how this came about, with some original centres surviving while others disappeared from the street scene. There are also marked differences within the locality as to why, in one area, house building was slow to develop. It makes sense to look at one area at a time and in so doing, we can begin to see the benefits of taking a walk to see the place more clearly on foot.

Five points of entry into the village reveal the way and the direction in which Harefield has grown and as they all meet near the green, it makes a good starting point. The green lies at the heart of the village, at the convergence of five roads, so for the purposes of this study the village has been sub-divided into five geographical districts, as though one were walking each part. The component parts can also be justified by their very different characters, which reflect the circumstances that brought them about.

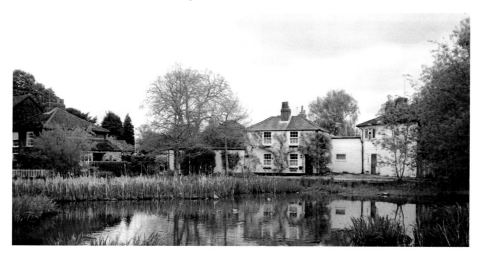

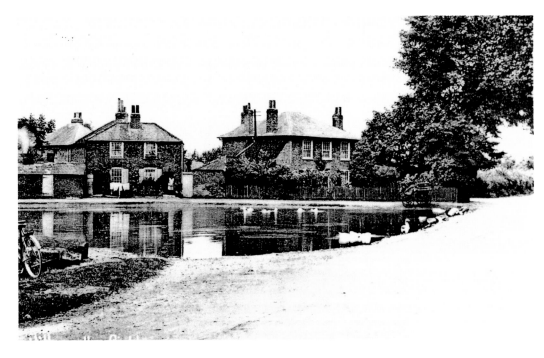

The Village Green

Whichever route is taken out of the village, a pedestrian will be rewarded with a variety of architectural styles and environments, which require more time than is allotted here. By taking the first route from the village green to Breakspear House, the pedestrian is given the option of either returning to the green in reverse, or taking the footpath to St Mary's church and the High Street.

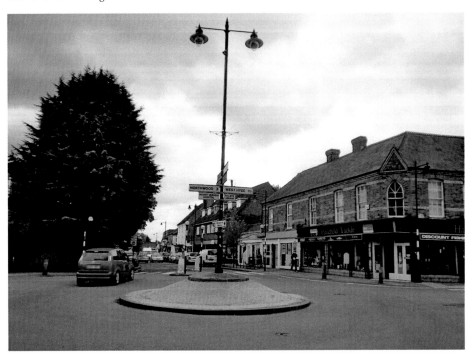

Breakspear Road North
The First Journey Through Time

Travelling East from the Village Green

In exploring the east of the village, the visitor is welcomed by a village sign, which takes the form of a globe showing Britain and Australia, with a hare offering a play on words. Nevertheless, the close, longstanding relationship of the town and its symbol is of particular importance. What might be considered a humorous feature elsewhere deserves a deeper respect here.

Breakspear Road

The roads meet by the village green, where the King's Arms is a prominent feature. The pub is said to date back to the fifteenth century and to have been rebuilt in the seventeenth century. Here on the green, with the traditional pond contributing to the overall design, is Harefield's memorial to eighty of its men who fell in the First World War, and to the thirty-one killed and missing in the Second World War.

Standing at the crossroads facing south is to look along the unpretentious High Street. To the right is Park Lane, which leads down to a small centre of industrial activity, maintaining the tradition set by the mills in the past, and from there over the canal into the Colne Valley.

Breakspear Road has the appearance of a country lane, but in providing access to Breakspear House itself, it was clearly a road of some significance.

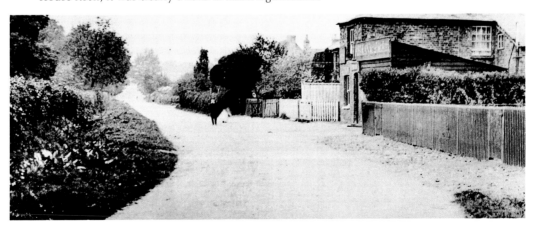

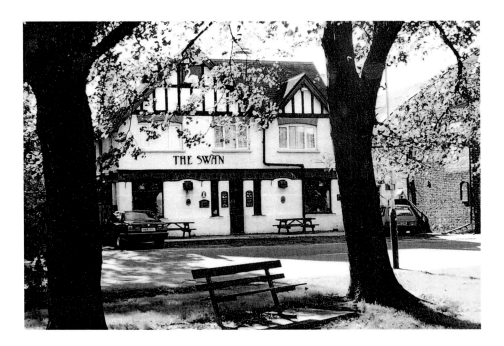

The Swan

Breakspear Road marks the way to Ruislip and this recent redevelopment of the site of The Swan is located on the south side of the green. This is another public house lost to the developers, but enough careful treatment has been given to its public façade to enable it to contribute something to the street scene. The glazed tiles that once formed the pub sign have been retained. This is a two-storey building of two one-bed and four two-bed flats for Clearview Homes (Architect: W. J. Macleod), built in 2012. The Swan was built around 1900 by the local builder Charles Brown, who died in 1896 and was succeeded by his son of the same name.

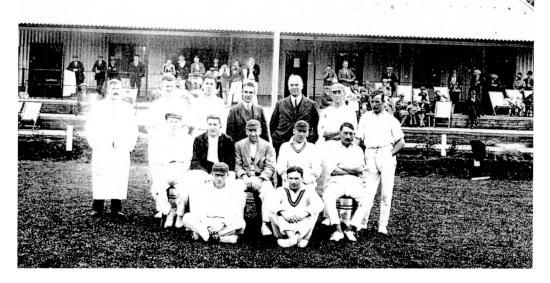

Breakspear Road

The views between the trees from around the pond towards the war memorial are a relatively modern creation, as is the village sign at the corner of the green. The design and location of the globe provides an added visual attraction.

The village sign was made as part of the Millennium celebrations and depicts the world as a metal globe, of which Australia and the UK are part, thus emphasising the special ties between the two countries; more will be said about this later. Breakspear Road gives access to the cricket and football grounds. Cricket has become an established sport on this site since the 1930s. The picture of the team dates from 1913.

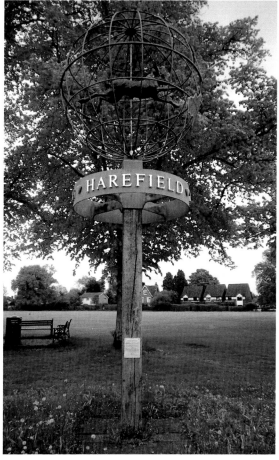

Trumper's Dog

A NOVEL GAME OF CRICKET. — A novel game of cricket was played, for a considerable sum, on Monday the 21st instant, on Harefield common, near Rickmansworth between two gentlemen of Middlesex, and Mr Francis Trumper, farmer at Harefield, with the help of a thorough-bred sheep dog. In the first innings, the two gentlemen got three runs, and Mr Trumper three for himself and two for his dog. In the second innings, the two gentlemen again got three runs, and Mr Trumper then going in, and getting two runs, beat the two gentlemen, leaving two wickets standing. Before the game began, the odds were 5 to 1 against Mr Trumper and his canine partner; but after the first innings bets were so altered, that four to one were laid on Trumper and his dog. The match having been much talked of in the neighbourhood for two or three weeks, and the day proving very fine, there was a numerous attendance of spectators, who were much astonished at the dog's dexterity. The dog always stood near his master when he was going to bowl, and the moment the ball was hit, he kept his eye upon it, and started off after it with speed; and, on his master running up to the wicket the dog would carry the ball in his mouth and put it into his master's hand with such wonderful quickness, that the gentlemen found it very difficult to get a run even from a very long hit. The money lost and won on the occasion was considerable, as a great number of gentlemen came from Uxbridge and the neighbouring towns and villages to see so extraordinary a game.

The Times, Thursday 31 May 1827
p. 3, Issue 13293
© Times Newspapers Limited
Gale document number: CS51270847

It is not exactly clear on which ground or common this match was played, as a number of pitches now appear on maps, but the 'common' is now taken to mean the green.

Today's club, Harefield Cricket Club, plays at Wood's cricket ground, which was founded in Breakspear Road North over seventy-five years ago. This originated from a conveyance to the National Playing Fields Association in perpetuity by Walter Wood in 1937, having previously been part of the Harefield House estate.

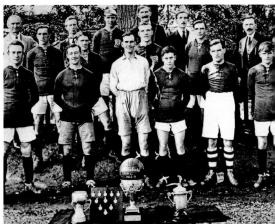

(*Left*) Brentford *v.* Harefield United in Middlesex Minor Cup, 1949. Feauring Alf Short (left) and Les Lake (right). Semi-final replay – final score 2-0 after a 1-1 draw. (*Right*) Harefield United club in 1922.

Harefield United Football Club
(*Red shirts, socks and black shorts*)
Along Breakspear Road North lies Preston Park, today the home of the 'Hares'. It is possible that a club (Harefield Victoria) may have been founded here in 1868, in which case the forerunners of Harefield United Football club would be the oldest in Middlesex. The football matches that would be played on the local common arose as a winter pastime to replace the games of cricket played in summer. Victoria, the football club, had their origin in the Australian state of the same name, and the village also had a cricket club (who were based at the memorial hall from 1863). The first written instance relating to the football club was in November 1891, when the team not only beat Rickmansworth Rovers but the vicar's son, Gowan Harland, played on the winning side. However, a newspaper report on an amateur athletics meeting in February 1892 under the auspices of the Victoria Football Club was said to have been the first of its kind in ten years' past. A further newspaper report in 1888 referred to the Harefield Victoria Cricket Club and its annual concert in this, its twenty-fifth anniversary year.

There was certainly a meeting held to form another club called the Breakspears Institute Football Club on 22 September 1896 after Harefield folded around 1903, but subsequently various teams have had any number of name changes and mergers. Harefield United was formed in the summer of 1936, probably from a merger of two other village teams. It originally played in local leagues and has done remarkably well, given the small crowds it attracts. It first became a member of the Spartan League for the 1971/72 season, and after a time in the Athenian and Isthmian Leagues, returned to the Spartan and continued when that league merged with the South Midlands League in 1997.

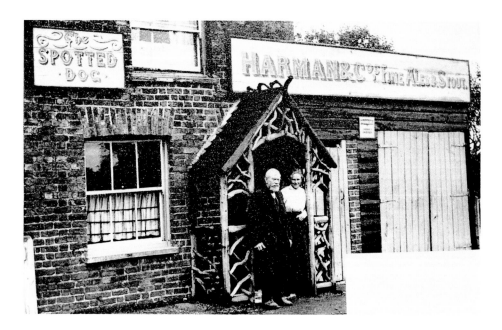

Spotted Dog

The sports grounds front the south side of the main road, while opposite, a mixture of properties, from the Victorian post office on one side of the Northwood Road junction and a retail shop dated 1929 on the other, give a correct notion of slow expansion. The present row of semi-detached houses and the rebuilt Spotted Dog appear to date from the same inter-war period. The original Spotted Dog features in the picture above, while the picture below looks from the pub back to the Green. This public house stands on the site of cottages built by James Matthews and Benjamin Babb, which were sold to an Uxbridge brewer in 1831. On approaching its destination, the road passes what began life as a workhouse.

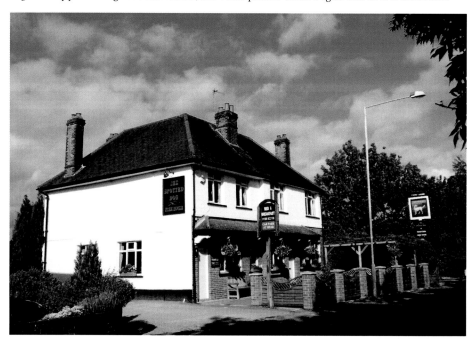

The Workhouse

The Harefield Workhouse was built in 1782, to the north of what is now Breakspear Road North, to house the poor of the parish. Numbers housed here clearly fluctuated, with ten being admitted in 1803 and twenty-nine in 1815. Originally, groups of parishes formed unions to share the cost of relief, but such poorhouses were conceived to look after the old and sick, not able-bodied poor. The Poor Law Act of 1834 took the responsibility away and gave it to a central authority, and the Harefield Workhouse closed in 1834 as a result. In the nineteenth century, the building was divided into cottages for workmen on the Breakspear Estate, which was broken up in 1923 following the death of the then owner, Captain Tarleton.

In 1974, the building was listed, but while adjoining sites were sold for development in the early 1990s, one of the properties being named Trumper's Cottage, the workhouse not only survived but received a blue plaque because of its connection with Robert Ryder VC.

Robert Edward Ryder VC was born in 1895 in one of the cottages into which the workhouse had been converted, becoming the youngest winner of the VC in the First World War.

On approaching the end of our journey, this particular historic landmark is worth visiting.

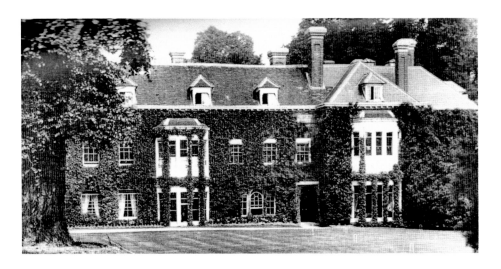

Breakspear House

Breakspear House was the family home of William Breakspear, who was resident in Harefield in 1376. Two centuries earlier, there had been a Nicholas who, as Adrian IV in 1154–59, was the only Englishman to have become Pope. No connection between Harefield and Adrian has ever been established. By the beginning of the 1600s, however, the Ashby family had assembled a large estate known as Breakspears.

When, a few generations later, in 1769, the descendant Robert Ashby died, he was the last male heir of the family, so ownership and, with it, responsibility for the building passed through a number of families. Breakspear House has struggled to survive in recent times, and had something of a chequered history until restoration work safeguarded it for future generations. In its recent history, the house has largely been let out and one of the prominent lessees was Commander Alfred Tarleton. He came to live here around 1890. He had joined the Navy in 1872 and had left the Active List in 1888. In that year, the house provided temporary accommodation to W. S. Gilbert. While resident here in 1888, Gilbert wrote the libretto for 'The Yeomen of the Guard' before moving to Grim's Dyke in Harrow Weald. Before Tarleton died in 1921, the Tarletons lived here in considerable state, while serving on the local bench and the parish council, and at one time employing twelve indoor and seventeen outdoor servants.

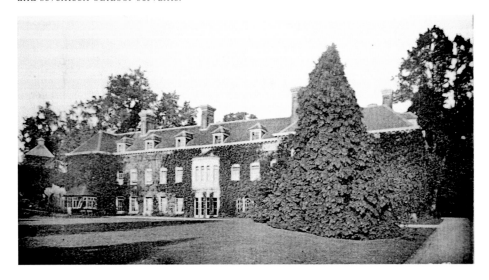

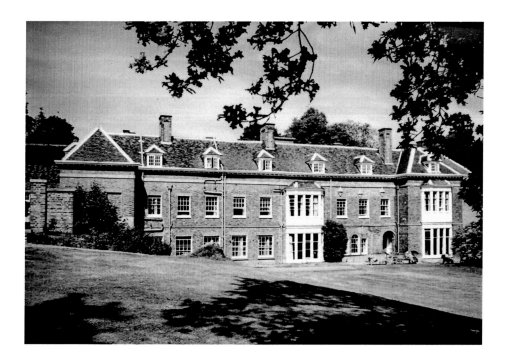

Restoration and Conversion

The house became a residential home for the elderly in 1956–87, but thereafter had an uncertain future. However, building commenced in 2009 to convert this part-sixteenth-century house into twenty apartments and luxury houses. Set in attractive grounds, which include 9 acres of woodland and an underground car park, the house has been restored with meticulous precision by Clancy Bros, the house being converted into nine two- and three-bedroom apartments. The lodge houses have also been restored. Eight three-storey coach houses formed part of phase two. The completed accommodation was sold in 2013.

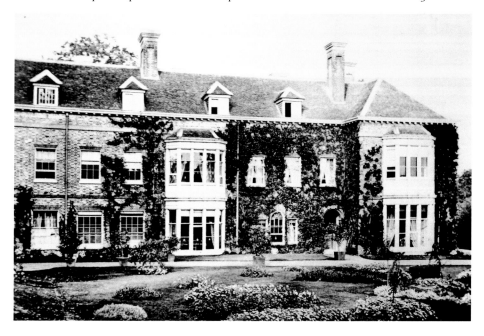

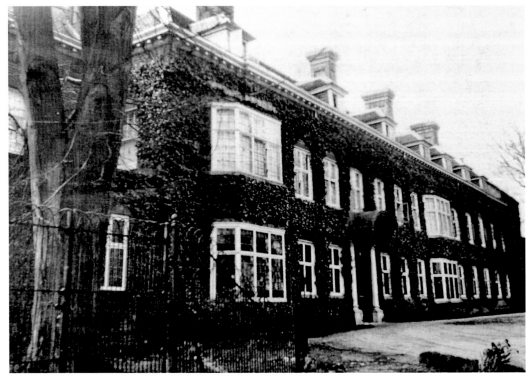

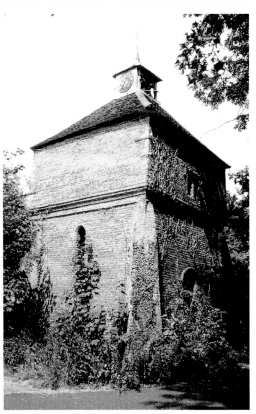

The Breakspear Estate

For those seeking a different style of accommodation that is no less historic, the Breakspear Estate includes among its buildings the refurbishment of the dovecote, walled garden and clock tower. The square, red-brick dovecote, which is of considerable size, was built around 1640 and adds to the character and history of this site.

The first Harefield walk reaches its destination at this point; it can be lengthened to link up with the next walk by taking the public footpath to St Mary's church and then by road to the green. Retracing one's steps would be quicker, but breaking new ground would give a taste of the mix of buildings to come.

The Village Centre
The Second Journey

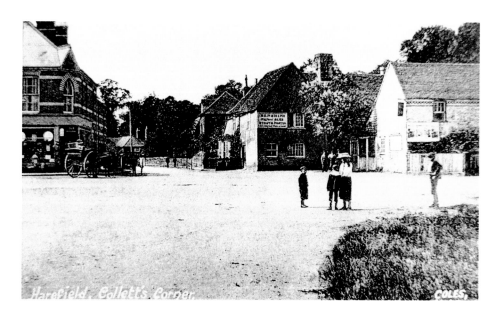

This chapter looks at the way the centre became established and some of the historic buildings that add to its character.

The next walk begins at the crossroads, where the commercial centre had already become established in Victorian times. Changes were taking place to buildings and their uses in the village centre and these are evident from the following glimpses.

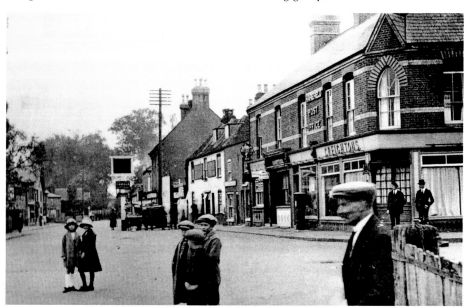

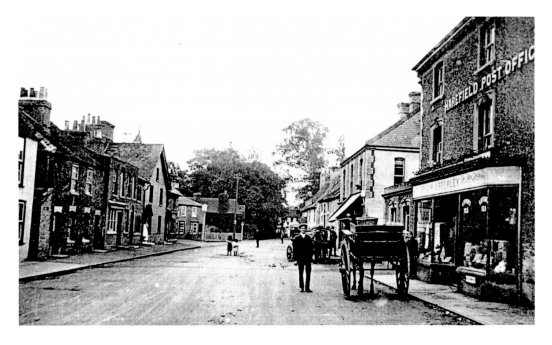

Development

The publication in 1978 of the Harefield Local History Group looking at life in a Middlesex village from 1800 to the 1930s confirmed how slowly, or indeed how little, change had taken place. It has been the post-1940s developments that have had the most profound effect in terms of scale of development, such as schools, hospital and housing estates, and the accompanying map shows the gaps that Geoffrey Tyack identified would soon be ready for development.

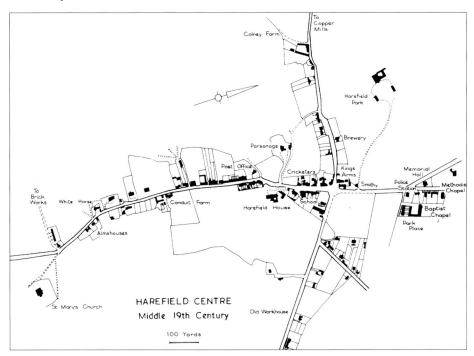

HAREFIELD CENTRE
Middle 19th Century

100 Yards

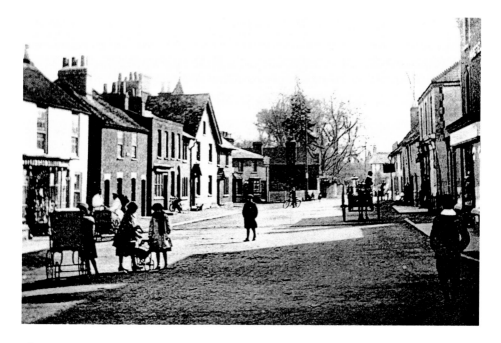

The Village Centre Shops

At the beginning of the twentieth century, Harefield was still mainly an agricultural area, but within a period of barely sixty years from the mid-1940s, it has changed its form and function almost beyond all recognition. The trade of businesses in the village centre reflects the goods in demand by residents and the limited range of goods that people could afford to buy.

The ground floor of the former post office was in use as a baker's shop in 1839–89. The functions of such family-run businesses tended to survive, though some uses became less important, like the saddlers next to the Cricketers, or the blacksmiths, which have disappeared altogether from the scene. As a relatively isolated village, it has had to adapt, but not to the extent that larger chains transformed the appearance and character of the area.

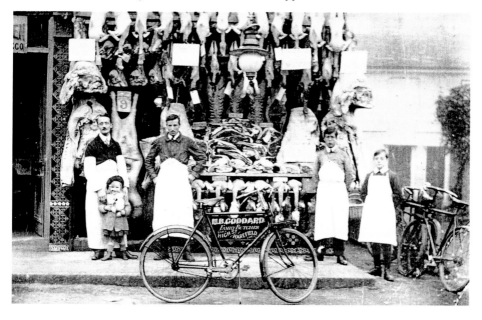

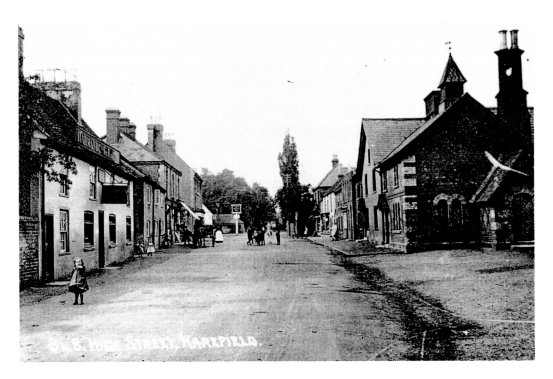

The Character of the Frontage

Shop uses, encouraged by competition and giving the customer something new, dictated longer servicing and opening hours and a more arresting shop window design, using aluminium instead of wooden frames. These, in turn, shaped the size of retail area and over time impacted upon the frontage design and use of materials.

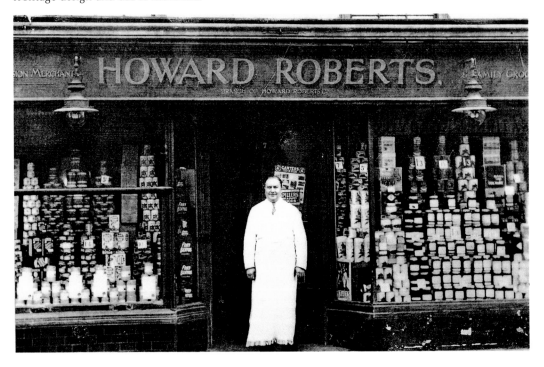

The Changing High Street

Harefield's Roman Catholic church in Merle Avenue, which was opened by Cardinal Heenan in 1965, did not take advantage of a main road frontage. This would have given the church a more imposing appearance at a time when the High Street was changing. Consequently, like its Anglican counterpart, it is a little hidden from view down a side road. It was Father Keane who was instrumental in getting the church built and all credit to him for that achievement prior to his retirement in 1976. The entrance to the vicarage can be seen to the right of the photograph above, which shows the High Street around 1900 looking towards the Kings Head and the butcher's shop.

There has been a church at the end of Harefield's High Street since the time of the Domesday Book (1086). That doesn't automatically imply a resident minister and indeed, where there has been a curate as well the vicars have needed sizeable accommodation. The first curates stayed in the Almshouses. The Victorian Vicarage of 1852 was the home of Revd Albert Augustus Harland for fifty years (1870–1920).

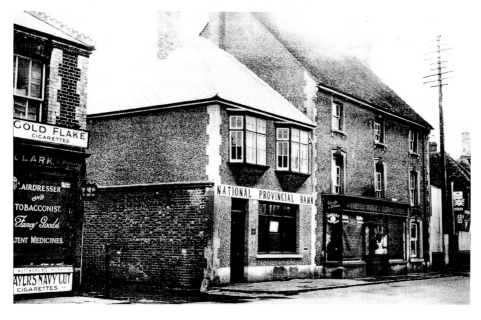

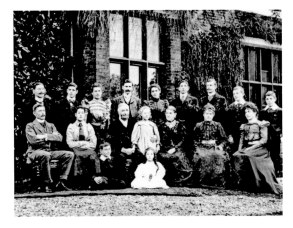

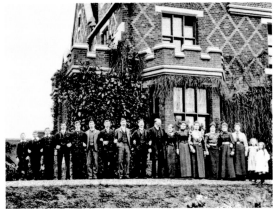

Vicars and Their Accommodation

Revd Harland (1839–1921) with his wife, Louisa Ellen, had a family of sixteen children (nine sons and seven daughters) surviving childbirth, born between 1865 and 1892. They required an extensive house. In 1868, the vicarage lay behind the shops in the High Street, overlooking what is now the infant school, and it was still there in 1916. Harland was succeeded by the Revd Cochran until he retired in 1927. It was sold for development in 1929 but survived until the 1950s, before being demolished for a block of flats, now Harland Court. The spacious Cumberland House, which the builder, D. C. Collett, built for himself, was taken up by another vicar, and it was his retirement in 1995 that triggered the redevelopment of the whole plot in which Countess Close now stands.

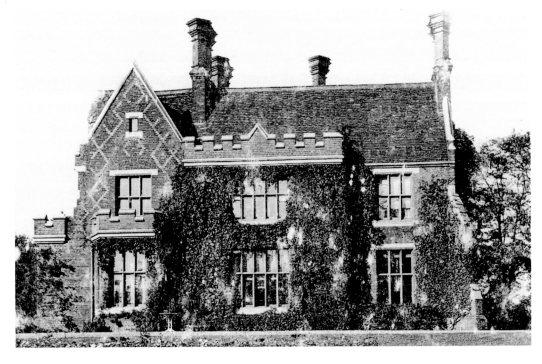

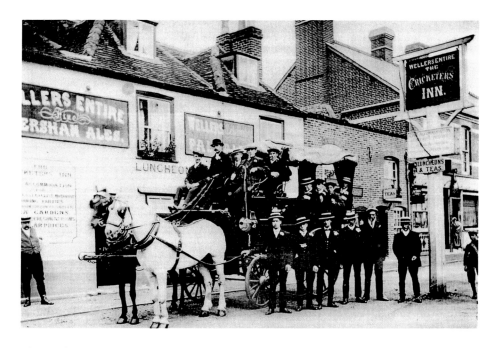

The Cricketers

The Cricketers was a popular venue and one of some thirteen pubs in Harefield. It was located in the High Street with its pub sign standing in the highway. In the 1790s, it was known as the Bull and Butcher and became the Cricketers by 1804. The pub ceased trading in 1936 and was finally demolished around 1956. The Lord Nelson and the Rose and Crown were pubs at the southern end and on opposite sides of the High Street. The former was first licensed in 1884 and the latter in 1877. They both ceased trading around the first decade of the twentieth century.

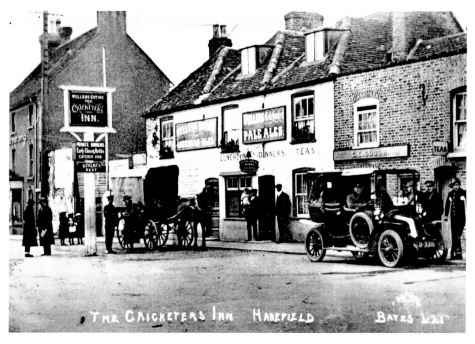

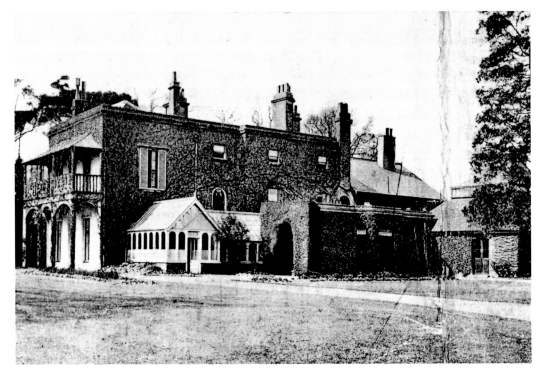

Harefield House

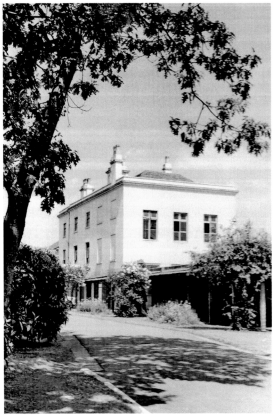

Harefield House stood in its own grounds on the east side of the High Street behind the retail frontage. The house had been built around 1764 in typical Georgian style and on land owned by the Newdigates. It was then sold by Charles Newdigate-Newdegate to Count Bruhl (1736–1809) in 1777. Hans Moritz Bruhl had been appointed the representative of the German state of Saxony and had married Alicia Maria Carpenter (1725–94), the Countess of Egremont. On its high ground, Harefield offered excellent views of the night sky. It was Bruhl who built an observatory and installed a Ramsden telescope, which King George III perceived as a series of 'gadgets' when he visited him in 1788. He was therefore able to keep a record of the partial solar eclipse seen in Western Europe on 5 September 1793, raising the reputation and importance of the village, which he made his permanent home.

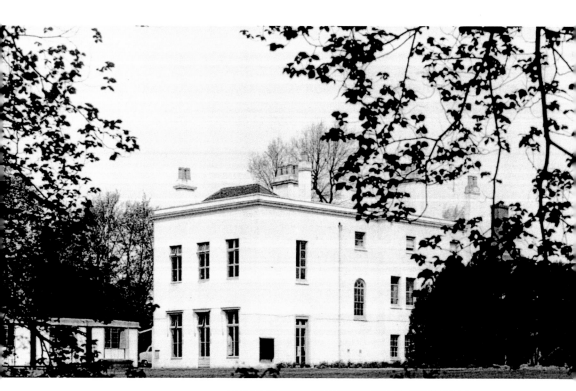

The Byles Family

Sir John Byles (1801–84), a famous judge of the time, was resident here from the 1850s and his son, Walter (*pictured right*), a barrister and member of the first Middlesex County Council in 1888, after him. Walter is pictured here. On his death in 1921, he was succeeded by the landscape architect, Henry Avray-Tipping. Helped by ten gardeners, Tipping created a showpiece garden. In 1923, he donated the land for the adjoining cricket ground and designed four houses for the main road frontage. Tipping's successor left in 1936, selling the property to the Air Ministry in 1937. It was then occupied by the Aeronautical Inspection Directorate, who tested Wellington bombers here during the war. Country and Metropolitan's development of 1994 has restored the house to residential and office use.

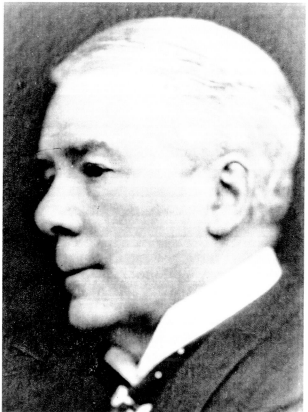

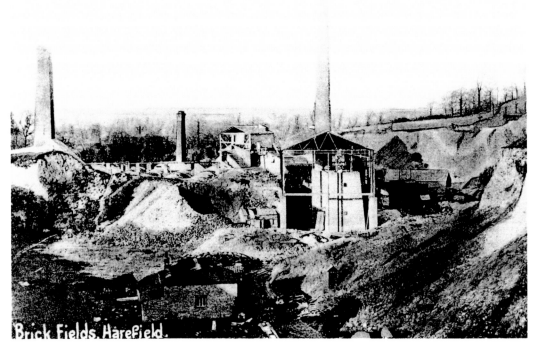

Brick Fields. Harefield.

Brick Making

Brickfield workers' cottages were built in Church Hill in 1916. Brick making was carried on behind the houses in connection with the lime works at Broadwater Farm. The cement works started here in 1910. The almshouses are on the right.

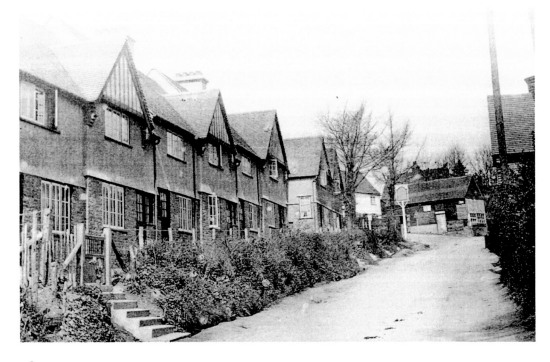

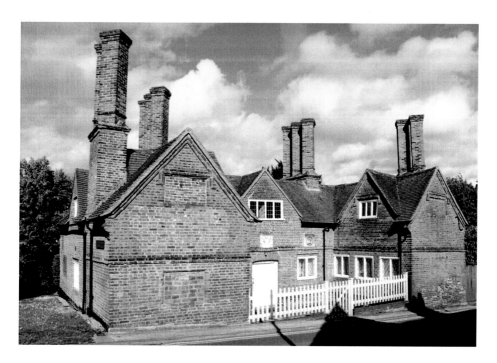

Countess's Almshouses

On the hill leading up into Harefield High Street is a remarkable survival from the seventeenth century, namely a group of almshouses built around 1637 under the terms of the will of the Countess of Derby. They were designed to provide accommodation for six poor women. They survived the threat of demolition in 1954, and now provide accommodation to four residents. They are built using a mellowed brick on an H-shaped plan and distinguished by ten tall diagonal chimneys.

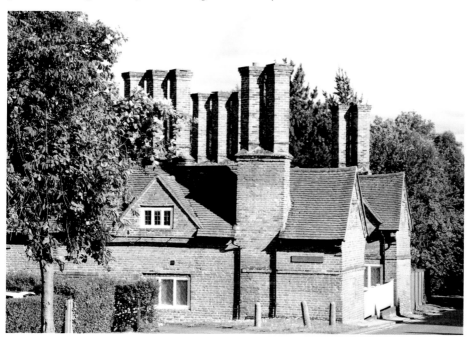

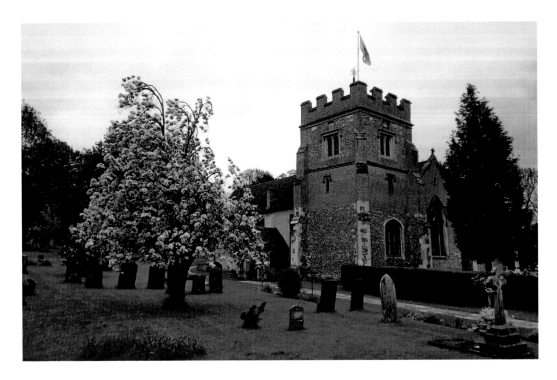

Long Drive, St Mary's Church

At the core of the village in terms of life's daily round lies the parish church, whose quiet exterior hides an astonishing interior. The church is to be found at Harefield's southernmost part, and is approached from an avenue of trees that line the route from the High Street down to the churchyard. These were once the 'branching elms' noted at the time of the royal visit in 1602. The elm avenue ran down from Dewe's Farm and was still in existence in 1820, which accounts for the present road name of Queen's Walk.

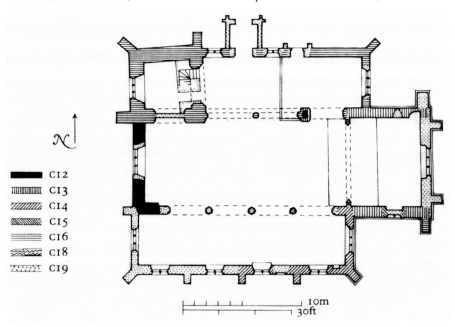

N

▬▬	C12
▥▥▥	C13
▨▨▨	C14
▧▧▧	C15
≡≡≡	C16
≈≈≈	C18
⠿⠿⠿	C19

10m
30ft

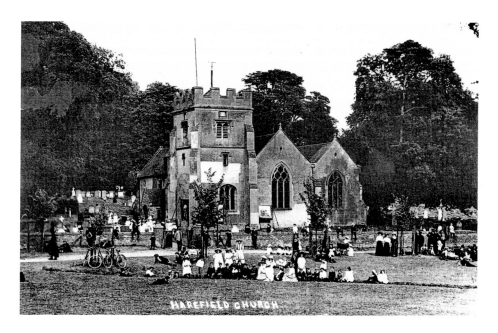

St Mary's Church

The church is striking in its simplicity. Set within the churchyard, the church has a squat rubble and flint tower, whose walls are topped by later brick. The original place of worship began with a simple structure – a main nave, chancel and side chapel, built within 100 years of the Norman Conquest. From the thirteenth century onwards, various aisles and additions were made to this basic form, reflecting the growing number and wealth of at least part of its congregation. Like the north aisle, the church is of sixteenth-century date, whereas the south aisle is 200 years older. Earlier still is the twelfth-century walling of the west end. Its later history is one of continual expansion. The rearrangement of monuments was carried out in 1841 by Charles Newdigate-Newdegate (1816–87) at a cost exceeding £3,000. Tasteful internal works have recently created an entrance lobby, or 'standing space' for the comfort of users.

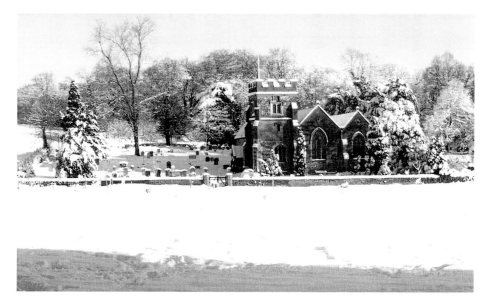

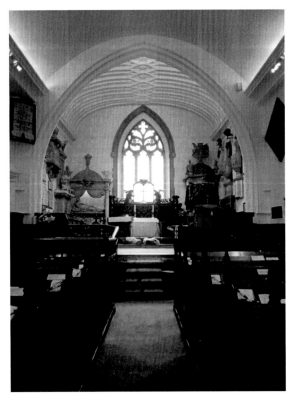

The Interior

Beyond the lobby lies the interior, with its impressive collection of wall tablets, effigies and hatchments. Indeed, the nave, chancel and decorative ceiling create a historic setting for such monuments. The impact of the carvings, the altar rails, reredos, boxed pews and the impressive monument to the Countess of Derby all make a tour of the interior an essential part of any village stroll, and time needs to be set aside for it.

The tomb of John and Amphilisia Newdegate, who died in 1528 and 1544 respectively, lies in the Brackenbury chapel. Their family was even larger than their son's, who was one of ten sons and seven daughters born to John and Amphilisia. Curiously, the date of the wife's death has not been inserted but the tomb is dedicated to their great-great-grandson, Sir John Newdegate (1570–1610):

Here wisdomes jewell, Knighthoods flower, Cropt off in prime & youthfull hower
Religion, meeknes faithfull love Which any hart might inly move
these ever liv'd in this Knights breast dead in this death w'th him doth rest,
so that the marble selfe doth weepe to thinke on that w'ch it doth Keepe
weep then who ere this stone doth see, unless more hard then stone thou bee.

Sir Roger Newdigate, the fifth and last baronet, made the family famous by founding a poetry prize at Oxford University. This, the Newdigate Prize, is an annual award for verses in English on ancient sculpture, painting, or architecture, limited to fifty lines.

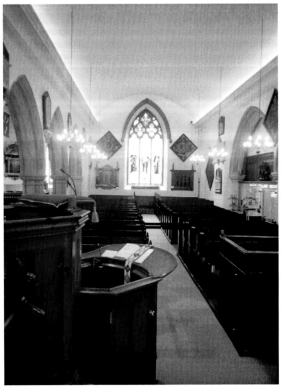

Monument to Alice, Dowager Countess of Derby

The impressive monument to the Dowager Countess of Derby stands in the south-east corner of the chancel. When, in 1585, John Newdegate exchanged his Harefield manor for the manor of Arbury, he began an interruption in his family's association that was to last for ninety years. After sixteen years, the manor was sold to Alice, Dowager Countess of Derby. Lady Derby's second husband (her first, the fifth Earl of Derby, was probably poisoned in 1594), was Sir Thomas Egerton, 1st Viscount Brackley (1540–1617), who framed the indictment against Mary, Queen of Scots.

Egerton bought Harefield Place for his wife Alice Spencer (1559–1637) in 1601. She came to stay here in that year and died here on 26 January 1637 (although the pre-Gregorian calendar used on her tomb says 1636; Britain ceased the use of the Julian calendar in 1752). Alice's monument is by Maximillian Colt, who carved the monument to Elizabeth I in Westminster Abbey. After Alice's death, Harefield passed to her daughter, Anne, and then to her husband. It was he, George Pitt, who, in 1675, sold Harefield Place and restored the manors of Harefield and Moor Hall back to Sir Richard Newdigate. Several decades earlier, in 1602, Queen Elizabeth came to visit Harefield Place for three days, from 31 July to 2 August, resulting in an itemised bill of:

'from 1s 7d for sope, 2 Ib.; carage of plumbes', to £177 15s to 'Walter Larke, for provision of beefe, mutton, lambe, and white'. Fifty-two dozen chickens (at 4d, each!), eight dozen pigeons ('tame and wild'), twenty 'pigges', thirty-eight partridges, sixteen pairs of 'calves feate', and twenty-three lobsters were among provisions; £65 18s 10d was paid for 'rewards to the vaulters, players, and dancers' £75 15s to 'mercers, the embroiderers, silkmen, and the Queen's tayler'; £24 16s. to 'Colin Wardes, for workmen, horschyer, and his owne labour with his man and kytchen necessarys which brought with him.'

Tradition has it that Shakespeare's Burbidge Company performed *Othello* for Her Majesty's entertainment in 1602. Elizabeth died in 1603, and *Othello* was published and performed at White Hall in 1604. Making such a claim is tempting but is as yet unproven.

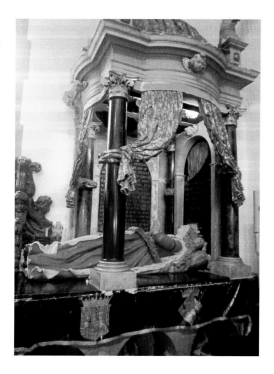

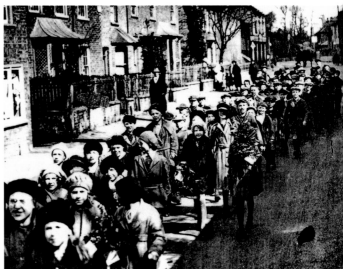

Harefield Place

The first reference made to the old manor house was when it was held by the Newdigate family in 1440. In 1559 it stood next to St Mary's church. There are records of Sir Thomas Egerton building a mansion in 1608, which was probably the one that a guest of Egerton's set fire to while reading in bed in 1660. In the eighteenth century, the Newdigates had chosen Arbury as their new seat and it was superseded in 1786 by a new mansion house, built by Sir Richard Newdigate at Harefield Lodge. Thereafter, the old Harefield Place fell into disrepair and in 1813 Jane Parker had most of it demolished. It was sold by Charles Newdigate-Newdegate in 1877, and then to George Rose to enhance his railway proposals. The Middlesex County Council intervened because of the loss of open space, but it was another forty years before the building was to be restored.

Anzac Cemetery

The First World War was a global war centred on Europe, which began almost a century ago on 28 July 1914. Of its worldwide impact, there can be fewer examples of commitment and sacrifice given by a nation in support of its distant motherland and the ties of King and country. The Australia and New Zealand Army Corps (ANZAC) Day is a national day of remembrance in Australia and New Zealand, held on 25 April to commemorate all Australians and New Zealanders who have served and died in all wars.

In 1915, Australians fought as part of the Allied expedition to capture the Gallipoli peninsula and Constantinople (Istanbul), the capital of the Ottoman Empire in Turkey. The landings met with stiff opposition, the Allied casualties rising to over 44,000. In response to the many wounded in April 1915, Harefield Park opened the doors of its mansion house to provide a 'clearing house' for the wounded with 1,000 beds. By the end of the war, 50,000 men had passed through the No. 1 Australian Auxiliary Hospital. The first patients arrived on 2 June 1915, with the hospital accommodation first being housed in tents and graves marked by wooden crosses. The first memorial service was held in April 1918. The Military Hospital closed in 1920, and the cemetery was formally laid out in 1921 with headstones and gateway and officially designated a Commonwealth Cemetery. The cemetery was laid out by the War Graves Commission, who continues to maintain it.

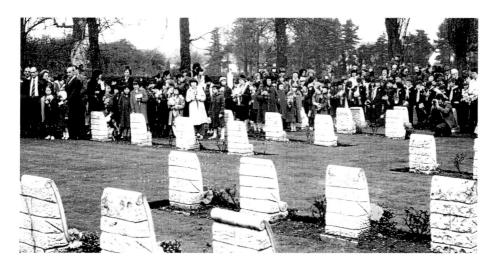

Anzac Cemetery

In Harefield, far from their Australian homeland, 111 men and one woman, a nurse from Sydney, who died of pneumonia in 1918, were laid to rest in this cemetery. There were also those who fell victim to the influenza outbreak of that year. The children's procession through the village, organised by the headmaster, was first held in 1921 with children also attending the service in 1921. The Anzac observance honouring the fallen has continued ever since.

Of the many others who have given their lives to King and Country and performed various acts of bravery are those who have been the recipients of the Victoria Cross. Reference has already been made to Robert Ryder, and in addition reference can be made to two others: Lt-Gen. Gerald Littlehales Goodlake (1832–90), who fought in Crimea, where he led a band of sharpshooters, and who is buried in St Mary's churchyard, Harefield; and Cecil John Kinross (1896–1957), whose family farmed Dewes Farm until they emigrated to Alberta in Canada in 1912 when he was sixteen. He received the Victoria Cross from King George V for acts of exceptional bravery in fighting at Passchendaele while serving with the 49th Edmonton Battalion, and was later buried in Lougheed Cemetery in Edmonton. Mount Kinross in the Rockies is named after him. Both Ryder and Kinross VC survived the war.

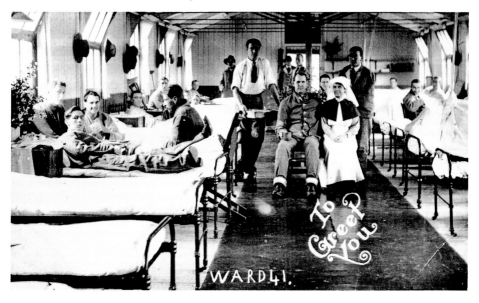

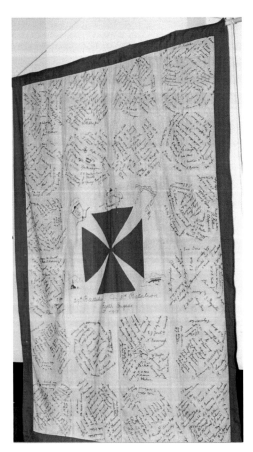

The Anzac Quilt

The Anzac Quilt was ninety-six years old this year. It was created in 1917 during the First World War, and is typical of many similar quilts made by volunteers of the British Red Cross Society. They were fundraising quilts, as for a contribution of sixpence (5p) or a shilling (10p), one's name could be embroidered by the organisers. This quilt has a central square showing motifs of a soldier, aeroplane, naval and cavalry of the 29th Battalion and 31st Battalion of the 8th Brigade 1917, the Red Cross emblem and the Advance Australia ensign. Twenty smaller squares surround the centre, each one with more than thirty names embroidered on it. The funds raised may well have been used to provide extra comforts for those in the hospital at Harefield Park from 1915 until 1921. The quilt was presented to the church by Mrs Emma Gough in 1972, having inherited it from her mother-in-law, Mrs Helena Gough, who had been a Red Cross volunteer.

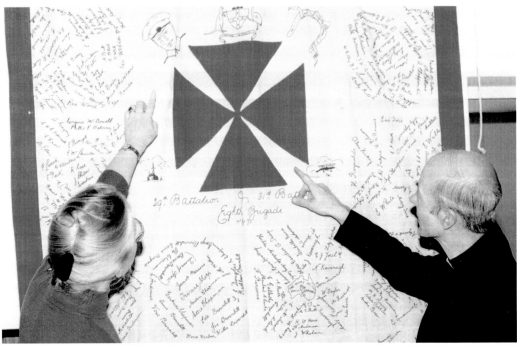

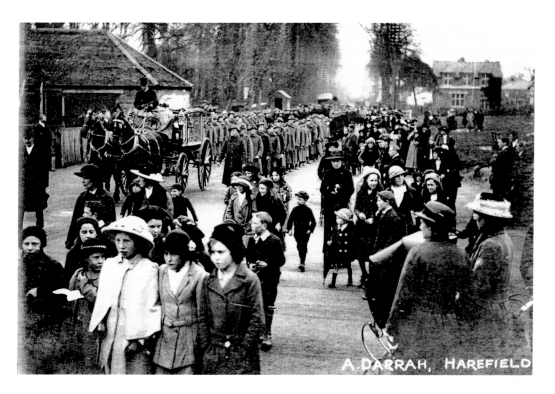

Funeral of Staff Nurse

Above is the funeral of Staff Nurse Dickinson, who died from pneumonia in 1918. She was highly thought of and a lady much devoted to her work. A measure of respect can be judged from the crowds who came to bid their last farewells. Shown below is the funeral of Private Wake in 1918.

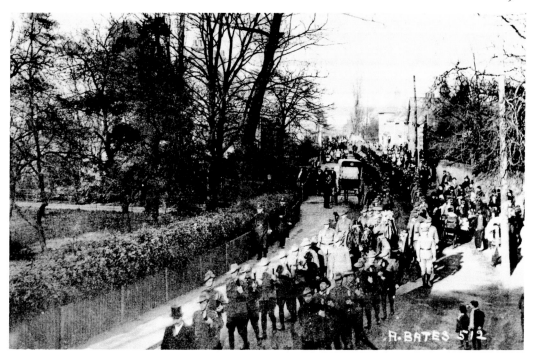

The Dogs' Trust

The Dogs' Trust bought Highway Farm from Hillingdon Council in 2004. Located in Harvil Road, the rehoming centre began operations from 2005. This had been a historic centre with a number of listed buildings, which included a barn. The 1950s saw the 13-acre farmstead, then owned by Hillingdon Council, affected by sand and gravel extraction, just as it is affected by the High Speed Rail proposals today.

The trust was founded in 1891 and is the largest dog welfare charity in the UK. Its location, amid 13 acres of farmland, provides a rehoming centre comprising seventy-five purpose-built kennels for over 150 dogs. It has eighteen such centres, which enable the charity to care for 16,000 dogs nationwide. It advises government on matters of dog ownership and gives a home to stray and abandoned dogs. It is as important to give dogs space to leave their kennels during the day as it is for staff to work with specific dogs to form a bonding relationship.

The routes followed so far have explored the east and south of Harefield. This has also allowed a closer look at the growth – and slow growth it was – of the retail and service facilities over the course of the twentieth century. There is another side to Harefield that I have yet to explore, and for that it is necessary to go back to around the time of the Industrial Revolution. That part of Harefield is very different from what has been seen so far.

The Industrial Past
The Third Journey

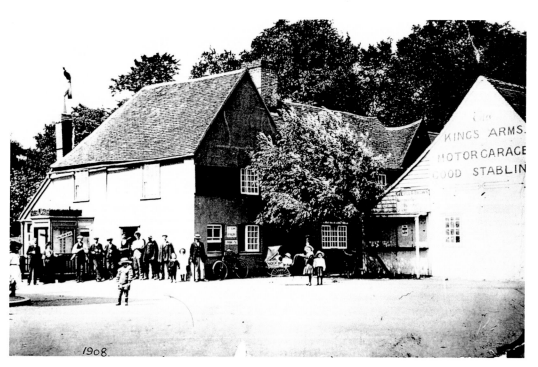

1908.

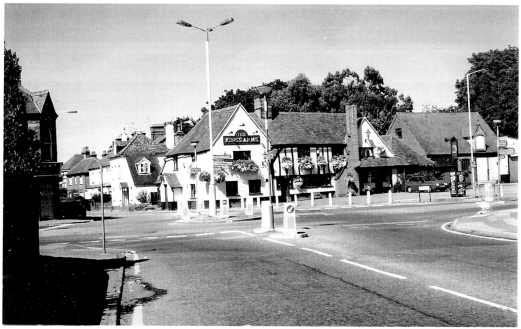

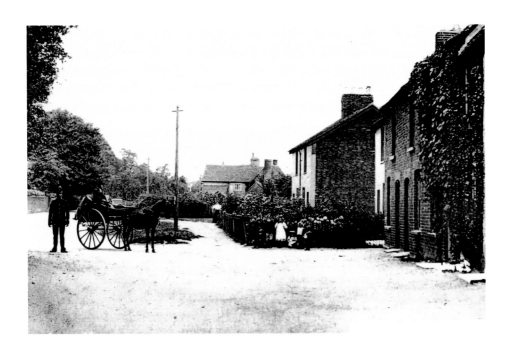

Park Lane

The domestic architectural styles in Park Lane are quite distinctive, and features such as the patterned brickwork are clearly indicative of the late Victorian origins of some of the properties. The present buildings on the street corner were acquired, demolished and rebuilt by the local builder, David Collett, in 1896. The window designs of the long terraces in Park Lane suggest a pre-war date of around 1908. The rear entrance of the Cricketers pub was set back from the road frontage, and, standing proud in the street scene, its hanging sign advertised the sale of Wellers beers.

Park Lane

David Collett described himself as a builder and general dealer and lived at Cumberland House, a Victorian Gothic edifice, until his death on 21 April 1918. In the 110 years since then, he sought a degree of control over his estate in death, as he had in life. The provisions of his will included setting up a trust to oversee the management of the housing he had built in Park Lane and his retail store Collett's Cash Stores in the High Street.

This would last for twenty-one years, until the death of the last surviving youngest descendant. On that basis, the trust's involvement in these affairs will be coming to an end in the near future. Such control appears unusual for the time, achieving some measure of temporary protection for property and tenant before the advent of housing and Planning legislation.

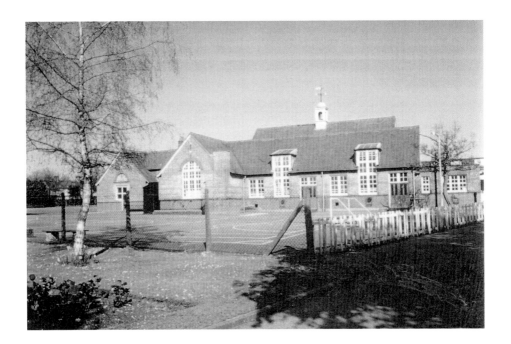

Library & School

Evidence from the end of the sixteenth century indicates the employment of a schoolmaster in Harefield, and by the early eighteenth century about 100 children were being educated.

The provision of education facilities was somewhat restricted before the state assumed responsibility for it. Until the Education Act of 1870, well-meaning, well-to-do individuals saw it perhaps as their public duty to provide not only for a schoolhouse but also a schoolmaster, as did Sir Richard Newdigate in 1692. The Church of England school was founded on the same site around the time John Penrose ceased to be curate. A state-run infants' school commenced in May 1871, and in 1880 attendance was made compulsory for children aged between the years of five and ten.

School

The first school in the Village High Street was that transferred from the Memorial Hall. It was a state-run infants' school built in an Arts and Crafts style on the church hall site. Groups from 1909 and 1916 are shown above and below. The last remains of the Cricketers pub were demolished in the 1950s, by which time a land deal had been struck to divide up the land so as to provide sufficient space for a library and junior school.

The first school in the Village High Street was built to replace the one that had operated in the memorial hall. It was a state-run infants' school built in a Victorian Gothic style on what is now the present church hall site. A third school, which was larger still, was built on the site of the present school in an Arts and Crafts style. It was opened in 1907 on the present site and was finally replaced in 1990. The last remains of the Cricketers pub were demolished in the 1950s, by which time a land deal had been struck, dividing the land so as to provide sufficient space for a library and junior school.

Today's junior school was built by the Mace Group and opened in 1990 on the same site. The bell tower and other features have been retained from the original building. This year, school numbers rose to 260 and with the completion of the new extension as well in 2013, the school will be able to accommodate 360 pupils.

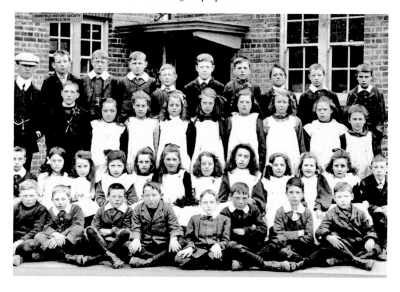

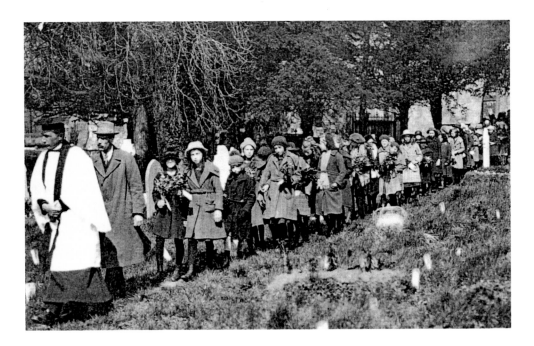

School

The school's association with Australia and Anzac Day, with schoolchildren attending the service and laying fresh flowers on the graves in the cemetery, started a practice that has taken place every year since 1918. Harefield is the only school in the UK to carry out such observance. The connection of the school with the present site in Park Lane can be traced to the opening of the junior school in 1907 and to the building of the infants' school, which followed in 1971. The old school in the High Street was demolished in 1971 to make way for the present church hall, which was completed in 1973. A school group in 1954 is shown below.

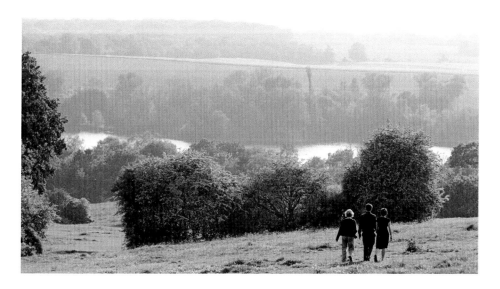

Colne Valley

At the junction of Park Lane with what older residents appropriately call Chalky Lane or Green Lane, the sunken lane descends the valley sides to the canal, opening up extensive views across the Colne Valley. Those views are a feature of the Colne Valley Park, which covers 43 square miles between Staines and Rickmansworth. The lane crosses the canal by Black Jack's Lock and continues as Jacks Lane to Coppermill, where it completes the circuit by rejoining Park Lane. The road itself passes first the hospital grounds and then the housing estate of Mount Pleasant, which was built around 1926. On the right are the Bell works and the Coy Carp. Gravel was extracted from the valley here in the twentieth century, and the valley's sixty lakes have been restored to provide a haven for wildlife in an area designated since 1965 as the Colne Valley Regional Park. The designation and policies aimed at protecting the area began as the brainchild of George Hooper, the Town Clerk of Hillingdon, who played a key role in bringing five authorities together.

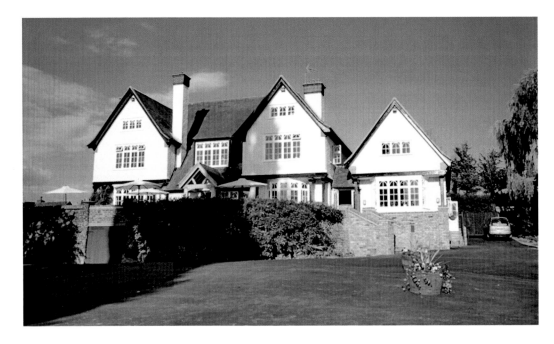

The Old Orchard

The narrow lane that reaches Black Jack's does so by way of the Old Orchard, contemporary with the housing estate at Mount Pleasant, on the other side of Park Lane. The Old Orchard appears to have begun as a country house and was bought by a Mr Gill in 1965 as a bed and breakfast and later became a restaurant with dinner/dance nights. It was trading as Edwinns when the present occupants took over in 2010, and has been run as a popular public house ever since. Certainly, one can sit on the terrace watching the red kites soaring above in the uplift, but the attraction of the premises must lie to a great extent in the quite extraordinary panoramic view of the Colne Valley from the car park.

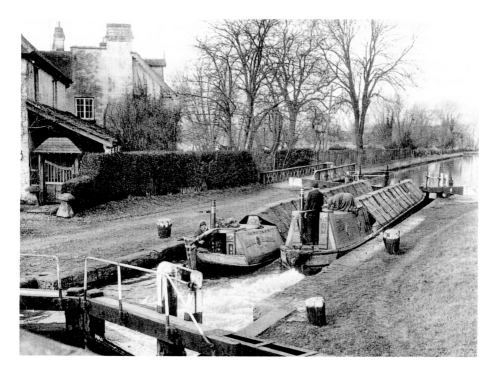

Black Jack's Lock

Black Jack's Lock is a working lock on the Grand Union Canal and the lock house was built in 1799. The Victorian mill on an adjoining island was named after it and was built in 1840. Despite such origins, its more recent use in the 1990s was as a restaurant. It currently offers bed and breakfast accommodation. Its 6-acre site includes three islands and four bridges.

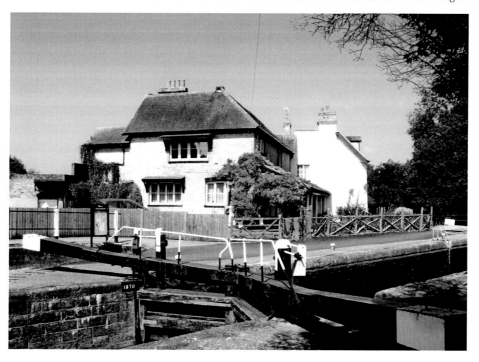

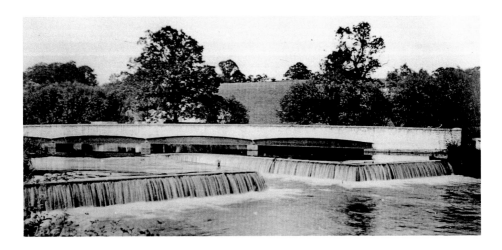

The Canal Age

The main line of what began as the Grand Junction Canal was built between 1793 and 1805, improving the connection between London and the Midlands, where a network was already under construction. Of a number of possible routes, Parliament passed a bill in April 1793 approving that William Jessop would be in charge of construction between Denham and Rickmansworth. The route of the canal proposed in October 1792 was to link the Thames with the Oxford Canal.

The canal served the chalk and lime works at the end of Summerhouse Lane; 29,258 tons of chalk were removed by barge in 1904, although this had fallen to 11,938 tons by 1910. However, this was replaced by the shipment of lime and brick works at Broadwater Farm.

Lime Bricks

The canal from Uxbridge to Kings Langley was finished in September 1797 and by mid-November, two months later, 47 miles of the main line were open and in use. Great delays had been caused north of Uxbridge by the nature of the ground through which the canal had to be built. Many miles of canal in this area had to have clay puddling, additional lining to make them watertight because the ground comprised sand and gravel – the very materials that 150 years later were highly sought after for excavation. The workings now provide a home for rare chalk plants. In addition, there was a brick field ancillary to the lime and then cement works from before the First World War. These had their works at the end of Summerhouse Lane.

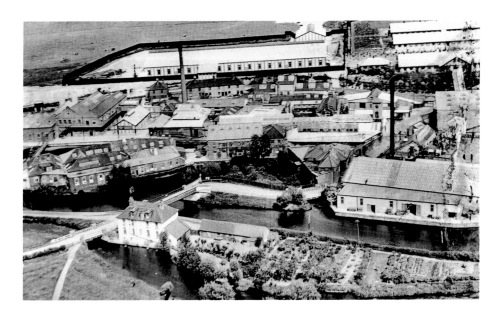

The Fisheries (Coy Carp)

The Fisheries Inn, as it was originally named, is now called the Coy Carp. It was probably built in the second half of the nineteenth century, although dates from the first half have been suggested as well. The aerial photograph is dated 1921. In the 1870s, West Hyde was a thriving village; the London and North West Railway had been opened, canal trade was increasing and there were lime kilns and mills producing copper, zinc and paper. The river also supported a successful watercress business, run by William Brad in the early nineteenth century, who lived in an imposing villa, Apple Grove, near the public house, which was open by 1871, when Henry Somers was the publican. The public house stands relatively close to the boundaries of all three counties, namely Buckinghamshire, Hertfordshire and Middlesex (but not, it seems, close enough to cause confusion) and initially served the canal trade. Now renamed the Coy Carp, it remains a popular eating spot. The road from Coppermill Hill on its way to West Hyde is shown below. (*Image above courtesy of English Heritage*)

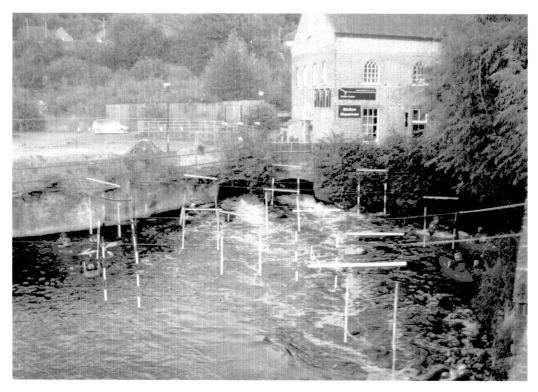

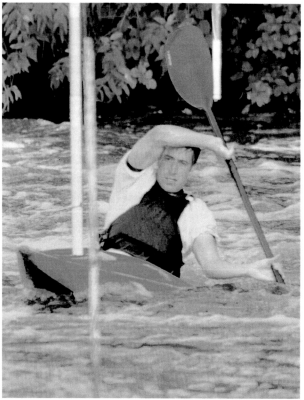

Canoeing on the Grand Union
Most canals were originally built for commercial use, including the transportation of heavy goods. To avoid silting up and keeping in regular use, canals have sought alternative uses for leisure pursuits since the 1970s, whether it is gracefully exploring the water courses or something far more vigorous and athletic. Hemel Hempstead Canoe Club has run both canoe slalom and canoe marathon events. Countless children and adults have been introduced to kayaking on the Grand Union Canal. Richard Fox, five times World K1 Slalom champion in the 1980s, trained here and more recently Richard Hounslow, silver medallist in the C2 Slalom at the 2012 London Olympics, developed his skills here. David Corner, three times world quadrathlon champion (2007–09), regularly trained here.

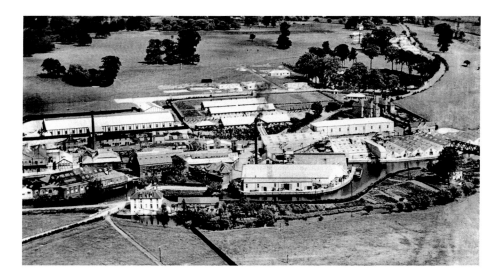

Copper Mill

Copper Mill is now a large industrial complex, but it started life as a water mill grinding corn, then, later, paper. The mills at Harefield were next converted from papermaking to copper rolling. The Copper Mills had begun by 1781/82 and had been let to the strangely named Mines Royal Company. In their time, the mills were a celebrated feature of Harefield, and by 1799 were already changing the character of the area. In 1830, the Mines Royal Company converted the mill to producing copper sheeting, which had been smelted in Glamorgan before being rolled into sheets in Harefield. The sheeting was used to protect the bottoms of wooden sailing boats. Trade at the mills declined with the introduction of iron ships. The Mines Royal Company closed them in 1863 and they were subsequently reopened at (Black) Jack's mill in 1870 to produce high-grade paper, only to go into liquidation once more in 1879. The Mines Royal was once a beer house known as the Rising Sun. Located on the west side of the High Street, the pub was mortgaged to Harman's Brewery in 1887, who then bought the premises two years later. The house and park and adjoining land was sold in 1908 to John Gutzmer Hossack, and the next year he sold on and joined up with the United Asbestos Company.

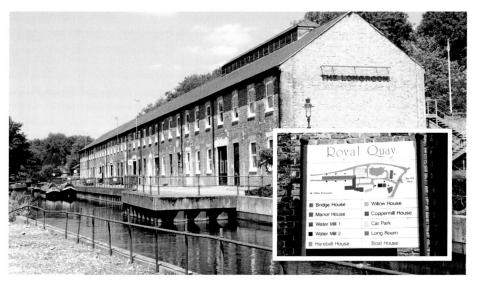

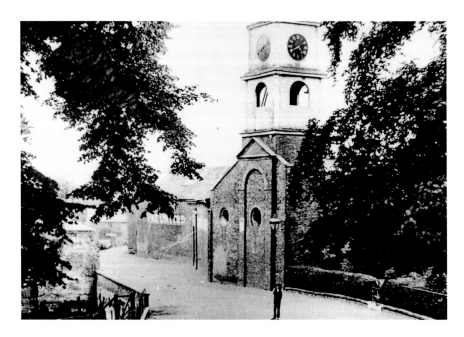

Bell's United Asbestos Company

The United Asbestos Company next leased the mills from 1882, using fibre brought in from Brentford and cement from the Coles and Shadbolt's premises at Broadwater Farm. The company was once one of the biggest employers in the area; the staff are shown below celebrating the end of the war in 1919. The asbestos company sold the mills in 1929 prior to the Depression and the loss of over 2,000 jobs resulted in severe unemployment. Three rubber companies came together in the 1930s to offer a rescue package. More recent plans to restore the buildings have been successfully carried out since a fire at the wharf in October 1985.

Excavating chalk pits from around 1800 led increasingly to the exposure of London clay, and brick making prospered in 1860–1920. Today, the canal passes through the Colne Valley amid disused gravel pits. The majority of gravel diggings are post-Second World War, though some are earlier; several have since become flooded and are a haven for wildlife.

Jack's Lane and Croda Paints

Reaching Park Lane once more, beyond Jack's Lane, are two pairs of Edwardian semis that were built as workers' accommodation for the Bell Works at the beginning of the twentieth century. Park Lane rises from the Coy Carp by the canal bridge to pass first the housing estate of Mount Pleasant built in the 1920s and then, further up on the left, the boundary of the hospital grounds.

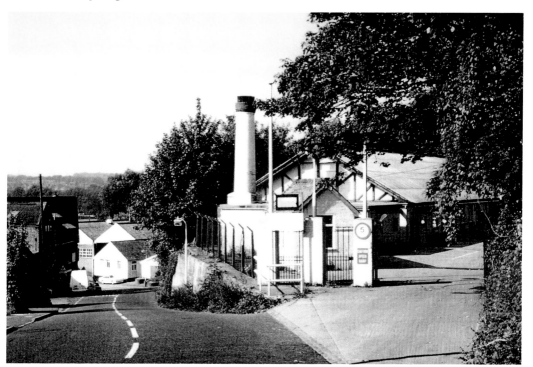

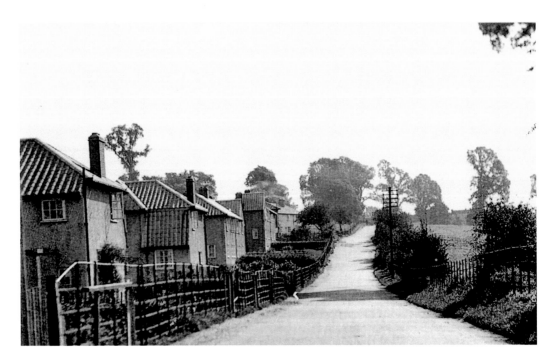

Mount Pleasant and Malthouse

In 1923, the council began constructing traditional, semi-detached houses on the Mount Pleasant estate. These are passed on the hillside at a point where the exploration of western Harefield returns the pedestrian to where his journey began – on the village green. The opportunity now arises to explore other nineteenth-century estates, which have contributed to the village's reputation over the past century.

Hill End Road & the Road to Rickmansworth

The Fourth Journey

This walk investigates the development of Harefield Park from an eighteenth-century country retreat, with its mansion, park land and lake, to a complex of buildings, which are now of worldwide significance as a specialist hospital.

The next journey begins at the green and follows the road to the hospital. The Breakspear Institute once stood on the right. It was a red-brick building erected in 1896, which comprised reading, smoking and billiard rooms. Beyond it was the Baptist chapel, which faced the world famous hospital on what was the Harefield Park Estate.

Harefield Park

Harefield Hospital originated in the Harefield Park Estate, which was centred on a mansion called Rythes, built by Sir George Cooke in 1710. Its setting was one of a grassed parkland grazed by a herd of deer. The old house within the grounds was rebuilt about 1740 and then inherited by Sir George (1675–1740) from his father. It was this house, called Belhamonds, that Billyard-Leake leased in 1896 and offered to the Ministry of Defence in Melbourne in 1914. Cooke's son, also George (1709–68), was related by marriage to Sir Roger Newdigate.

Both son and grandson were military men. Sir George Cooke lost an arm at Waterloo and renamed his house Harefield Park. Harefield Park lay on the north side of Park Lane, west of the Rickmansworth Road. It was here that Sir George Cooke (1675–1740) came to live following his marriage in 1700. He later became a distinguished lawyer and his son and grandson, both named George, lived here after him. It was the grandson, Colonel George John Cooke (1735–85), who bought the mills on the Colne from Sir Roger Newdigate in 1752. They were let to the Mines Royal Company, who converted what were paper mills to copper mills in 1781.

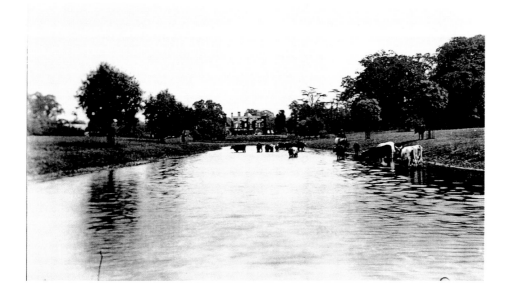

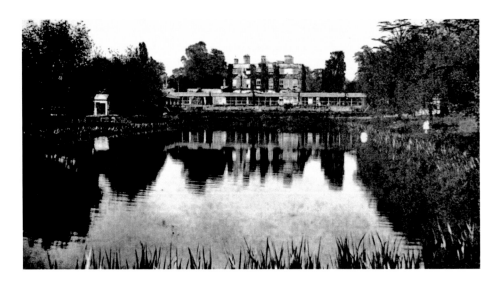

The Harefield Park Estate had in the meantime descended to Maj.-Gen. Henry Cooke, one of the estate's important residents. When he died without issue in 1837, it passed to his sister's son, William Frederick Vernon (1807–89). When William's brother, George Vernon, died in 1896, the estate passed to his son, Bertie, who was then living in Northampton. In July 1897, Vernon mortgaged a lot of the industrial uses in the Colne Valley and it was from him that Charles Billyard-Leake first leased the parkland in 1898. However, Bertie ran into financial problems and sold the house and park to John Hossack in 1908.

Leake, who had been leasing the park, bought it in 1909. The Leakes laid out a cricket pitch and gave skating parties on the lake, but as soon as war was declared, they offered their home to the Minister of Defence in New South Wales.

By the time the First World War had broken out, Leake had bought Harefield Park from the Vernon family to establish the No. 1 Australian Military Hospital in 1915. Servicemen who died there were buried with full military honours in the graveyard at St Mary's, on the south side of Harefield. Villagers were very involved in the designation and laying out of the Commonwealth Cemetery, and in every year since then Anzac Day has been observed. The cemetery is maintained by the Commonwealth War Graves Commission, who also erected the Gateway. The burial of the soldiers and nurse in the Anzac Cemetery is still commemorated today and the village has always provided spiritual support to the hospital. In 1915, the No. 1 Australian Military Hospital was established. The A1F hospital closed in 1920 and was replaced by the Harefield County Sanatorium in 1922. The ward blocks were built as an isolation hospital for TB in 1933–37. Changing needs and accommodation, however, allowed the hospital to expand its thoracic and cardiac services.

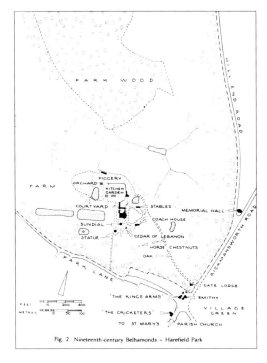

Fig. 2 Nineteenth-century Belhamonds – Harefield Park

Leading Figures in the Development of Harefield Estate

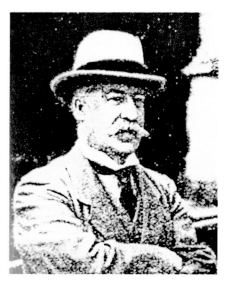

Charles Arthur Moresby Billyard-Leake (1859–1923)
At a time of war when Commonwealth countries were rallying together, Australia was seeking places where injured troops might recuperate. Charles Billyard-Leake, who was from New South Wales, decided to make his contribution to the war effort by offering the 250 acres of his home at Harefield Park for this very purpose.

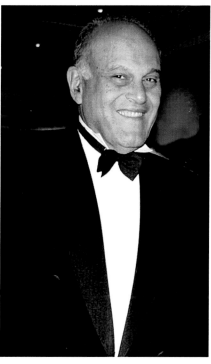

Sir Magdi Habib Yacoub (*b.* 1935)
Having studied at Cairo University, Yacoub moved to Britain in 1962 and became a consultant cardio-thoracic surgeon at Harefield Hospital in 1973. He was involved in the restart of heart transplantation in the UK in 1980 after a moratorium and then went on to perform more transplants than any other surgeon in the world. Although retired from performing surgery for the NHS, he has still pioneered a technique for switching heart vessels.

Of Other Names of Note
Thomas Wakley (1795–1862) was a medical and social reformer and founder of the *Lancet*. He lived at Harefield Park in 1845–56 and there is a memorial stone commemorating his work in the grounds of the hospital. Sir Alexander Fleming (1881–1955), biologist and Nobel Prize winner for the discovery of penicillin, was Regional Pathologist at Harefield Hospital in 1939.

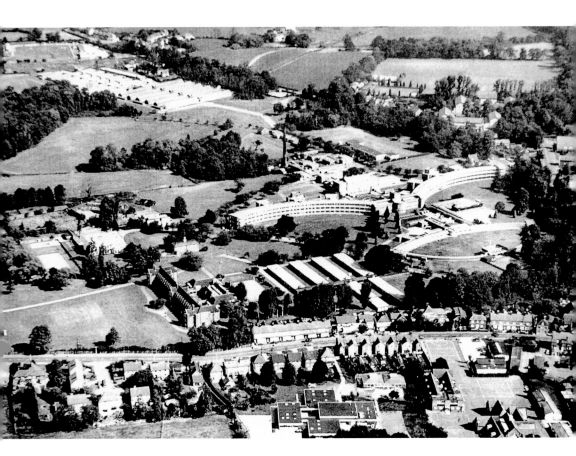

Harefield EMS Hospital, 1959

The burial of the soldiers and nurse in the Anzac Cemetery is still commemorated today, and the village has always provided spiritual support to the hospital. The diversity in patient populations is now reflected in a multi-faith prayer room, which was dedicated in 2010. There is a twenty-four-hour on-call team of clergy who serve patients and relatives.

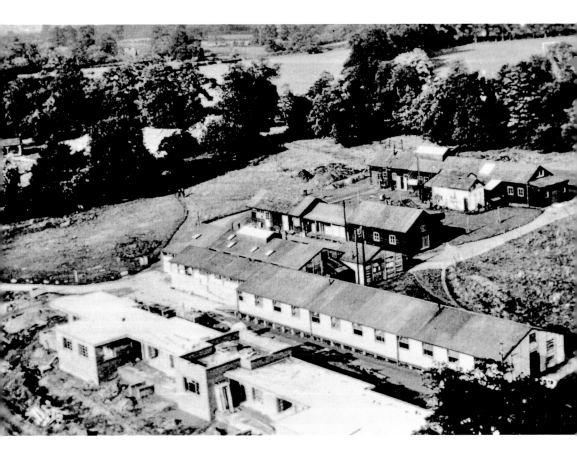

Harefield Sanatorium, 1935
In 1900 there was no disease so prevalent and fatal as consumption. Contracting the disease meant isolation in sanatoriums.

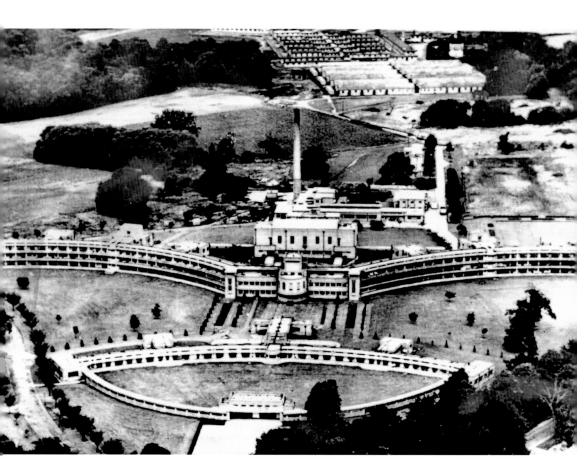

Harefield Hospital
An aerial view of Harefield Hospital and grounds.

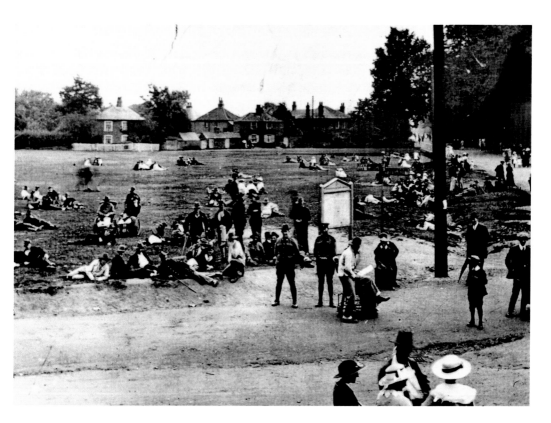

Rest and Recuperation

Above, Australians are seen convalescing on the village green, 1917. The 'Aussie' huts, shown below, formed a community on a site looking south to Park Lane. The huts were built to accommodate wounded soldiers.

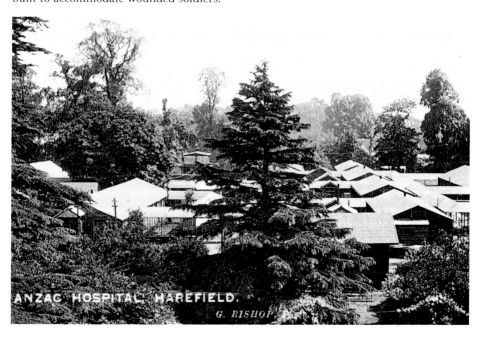

ANZAC HOSPITAL, HAREFIELD.

G. BISHOP

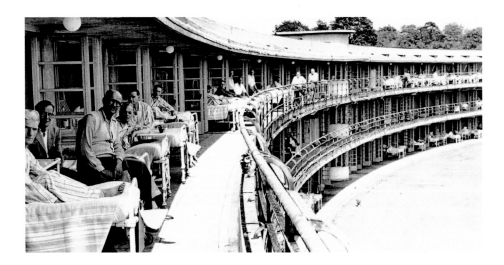

Surgical Advances

The very first heart transplant was performed in South Africa by Dr Christian Barnard in December 1967. The first heart and lung transplant in Britain took place in December 1983. The Swedish journalist Lars Ljungberg underwent the operation, which took a team of twenty doctors headed by Magdi Yacoub more than five hours. Mr Ljungberg survived for thirteen days following the operation. Britain's longest surviving heart transplant patient, John McCafferty, celebrated thirty years of extended life in November 2012 after once being told he had five years left to live. His surgeon, Sir Magdi Yacoub, and past and present transplant staff were there with other patients to celebrate with him.

The programme of research and patient care continues. The hospital has maintained its position as the leading UK provider of respiratory care and is a national leader in the specialist areas of paediatric cardio-respiratory care, treatment of congenital heart disease and cystic fibrosis.

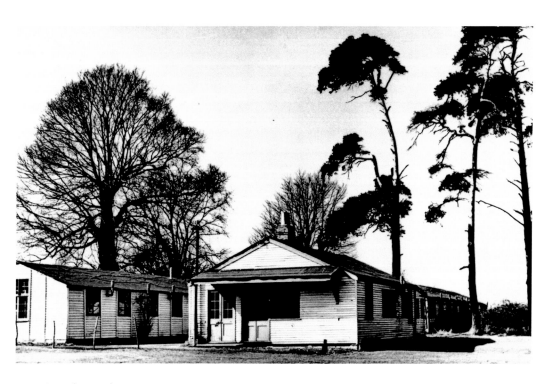

Mansion and Huts

Above, the last of the Aussie huts in the 1950s. Below is shown the original mansion house, looking more attractive here in 1989 than it does today!

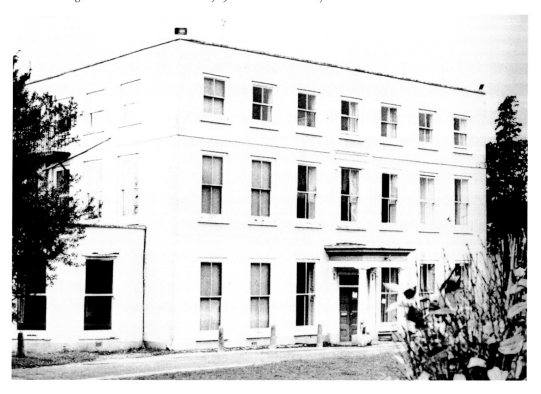

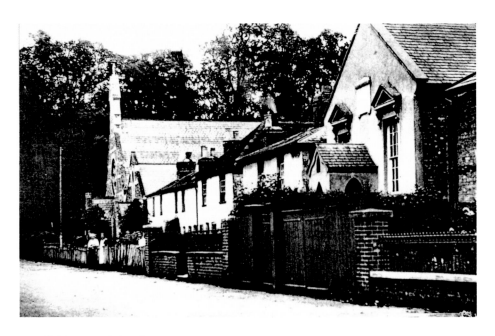

Harefield Memorial Hall

The Harefield Memorial Hall, shown here in 1909, was built facing the junction of Hill End Road and Rickmansworth Road. It was opened in 1864 and funded by Robert Barnes, whose only son had died while a student in Oxford. It was the only meeting place of its kind in the village and was demolished in 1969. The properties opposite in Chapel Row consist of 'book-ends' with the Baptist chapel, built in 1834 and standing on the right, separated from the Methodist chapel by a row of cottages called Chapel Row, which was built thirty years later.

Rickmansworth Road

There are two roads that run north from Harefield to Rickmansworth. One connects with Batchworth Heath and follows the main road to Northwood; the other is a country lane, which descends the slope and passes the Rose and Crown and the Tesco store in Rickmansworth, before reaching the White Bear beside the canal. Rickmansworth Road ran along the east side of the sanatorium and included the properties in Newdigate Road and the Baptist church. The houses in Newdigate Road are clearly identifiable as being built around 1896–1904, being deep in floor plan and narrow fronted. Originally, the accommodation is believed to have been built for farm workers.

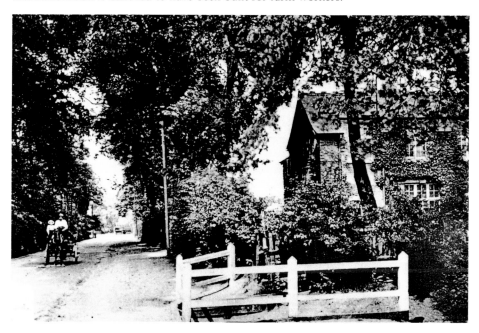

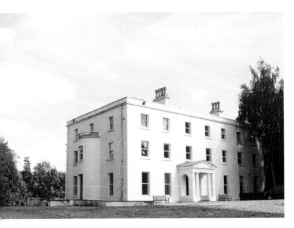
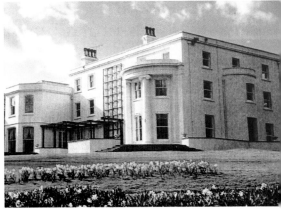

Harefield Grove

The Harefield Grove Estate, formerly called Guttersdean, lay on the east side of Rickmansworth Road and comprised a mansion and parkland. Established between 1518 and the mid-1600s, when the Ashby family were resident, it was acquired in 1753 by Edward Jennings, who became a successful lawyer in the Inner Temple. He built a new house on the site and died in 1774, but the house seen today is largely the work of Stephen Morgan, a Russian merchant, who rebuilt it in 1836–60. A series of occupants, including Robert Barnes in 1861–67 and Sir Francis Newdigate-Newdegate in 1933–36, lived at the premises. It largely remained empty in the 1970s, but was used for films like *Black Beauty*. The Grove is a private house with no access to the grounds and cannot be seen from the road.

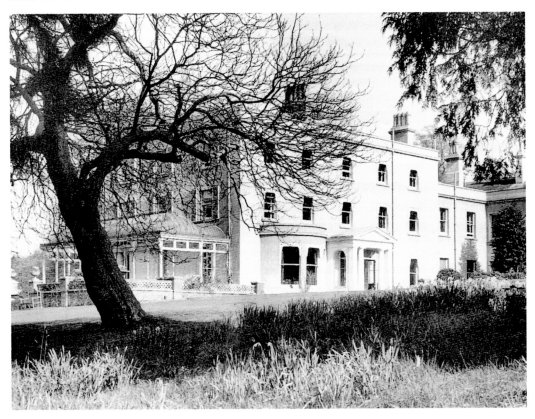

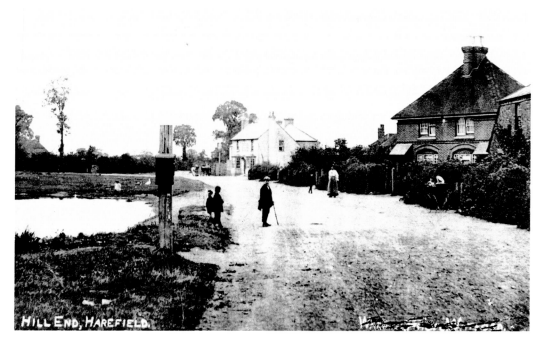

Hill End in 1921

The Vernon Arms formed part of the hamlet of Hill End in 1920, and at that time the sheep washing pond provided an attractive setting. When William Vernon inherited the property, the beerhouse was named in his honour, but far from being a latecomer, the development of this hamlet can be traced back to the early 1500s. Indeed, the sixteenth-century barn at Cripps Farm is evidence of a long history, and Hill End Road continues its route leading to Springwell Lane as a winding country lane.

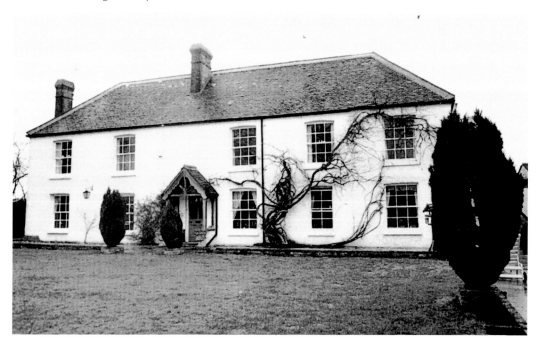

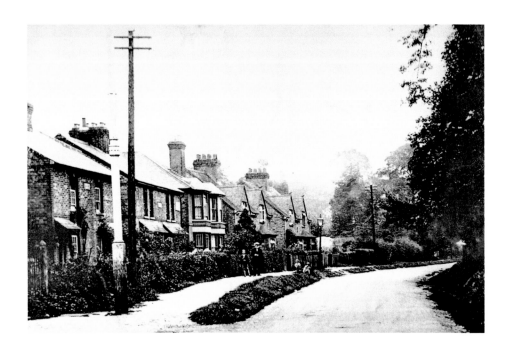

Hill End in 1932

The Enclosure Act brought changes, with roads being fenced off and new ones built. An example of this is here at Hill End. It is clear that while village growth was slow to begin with, by the time 1932 had arrived Hill End was already showing signs of new buildings and cottage expansion. Cripps Farm was sold to George Cooke as an addition to his Harefield Park Estate, and later in the nineteenth century the farm was rented to the Trumpers, a local family. Cripps Farm was a sixteenth-century property on Springwell Lane, which underwent a number of improvements or 'make-overs' in the post-war years. Today, the Plough, seen below, is no longer a public house, although the building remains.

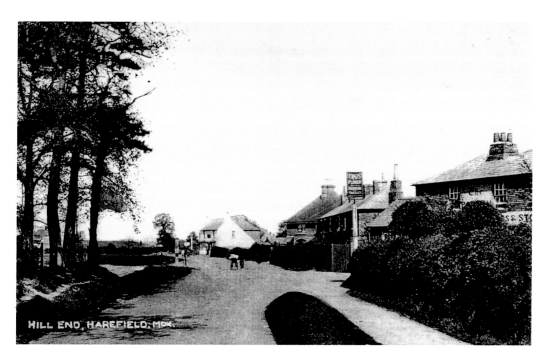

HILL END, HAREFIELD, MDX.

Hill End: Plough and Vernon Arms

By 1861, there were two pubs, the Vernon Arms having been built on part of the heath, which was enclosed in 1813. The road from the village green continues, in fact, to Hill End and beyond to the hospital.

By the lane to Weybeards Farm, the road becomes Springwell Lane, which led to the spring water bottling plant. There is a disused chalk pit above the valley floor, where watercress beds once flourished. Though none survive now, they were famous in their time for their quality.

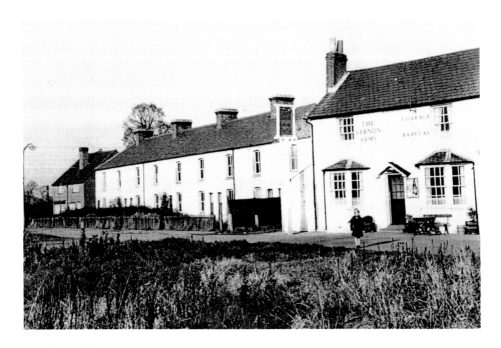

Hill End in 1934

Springwell Lane's watercress beds were famous in their time, and in its day, the bottled spring water was of similar merit. There are numerous other pits that can be accessed from Summerhouse Lane, where a quarry was developed for the production of lime. The workings now provide a home for rare chalk plants. In addition, there was a brick field ancillary to the lime and then cement works from before the First World War. The Harefield Lime Works, which had their works at the end of Summerhouse Lane, had their origins in the pits opened by Sir George Cooke in 1802. The nearby Vernon Arms public house, shown above, was later demolished to make way for houses such as those below.

Harefield Academy & Housing

The Fifth Journey

The fifth and final journey from the centre looks at post-war recovery and the housing and school that were expected to set new standards. The restriction in density and layout in house building in the 1920s and 1930s recognised that housing estates were built out from the centre along routes like Northwood Road. Building had begun in both public and private sectors, only to be halted by the outbreak of war. The building programme recommenced once incentives and building materials were back in place for recovery, which began around 1953. Residents recall the construction of the Ash Grove Estate as a council estate in 1953–55 along with the Newdegate Estate (on former allotments). Its 'planned' public open space followed in the late 1950s and early 1960s, along with the Gilbert and Sullivan road names. Perhaps earlier than Ash Grove, Merle Avenue appeared on the scene and here the Roman Catholic church was built in 1965. Returning to the Ash Grove, the careful observer will find exceptions to the general rule in dating some buildings by their bricks. The orange-brick houses with slate roofs are different again with their building materials, according to memory, coming from a brickyard near Rickmansworth. The traditional detached house design is set by the probably older frontage to Northwood Road (*below*). At the rear, the house types in Newdigate Road (*above*) show a pleasant variation with open grassed forecourts as well as street trees.

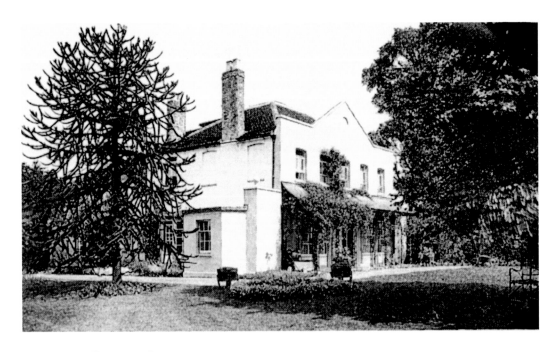

Shepherds Hill Farm and Nursery

Close to the school entrance and set back behind houses in Northwood Road stands Shepherds Hill House, and in its grounds there is a children's nursery. The house itself appears to be late Georgian in appearance, rather than the date of 1700 sometimes ascribed to it. Anne Partridge lived there with her brother until her death in 1855. It was last used as a family home in the 1930s. By that time, the first car had appeared in the village, owned by the occupier of Shepherds Hill. The post-1945 uses of the house, with intermittent periods of neglect, included a nurses' home, for which it was sold to the Middlesex County Council in the 1950s. It then passed to Hammersmith Council, who, until 1986, used it as a residential nature study centre for inner-city primary school children. The premises have been privately owned and run as a day nursery since 2006.

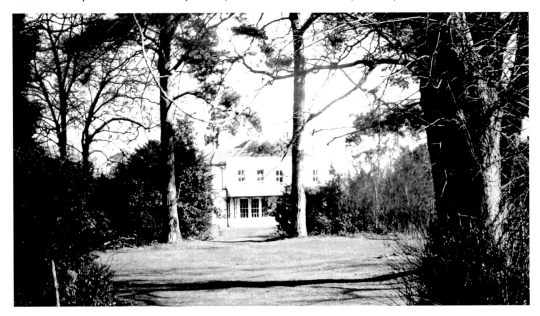

John Penrose School

The first secondary school on this site was typical of its kind in the post-war period, being of concrete frame construction and of light and airy appearance. On the west side stood the John Penrose Secondary School, which was built on land originally designated for the poor at the time of the enclosure and was opened in September 1954. There had been no secondary school in Harefield before this time, and it was conceived as an agricultural place of learning, befitting its surroundings. It later became part of the comprehensive system when that was introduced in 1977 and the sports hall that adjoined the school was opened in 1978. It was named after the Revd John Penrose (1778–1859), who had been born in Cornwall and was a junior minister and curate at Harefield between 1809 and 1814. He was the eldest son of the vicar, also John Penrose, and the elder brother of Mary Arnold, wife of the famous headmaster of Rugby School. His first ministry was at Marazion, Cornwall in 1801, which he left the following year.

John Penrose School

Penrose's first book, *An Attempt to Prove the Truth of Christianity,* was published in 1808. He became the vicar of Bracebridge near Lincoln in 1809, while at the same time living and teaching in Harefield (1809–14). In May 1814 he married Elizabeth Cartwright, a children's author and teacher. Writing under the pseudonym Mrs Markham, her History of England was about the only textbook on English history used in schools for almost forty years.

The photograph below shows the main buildings of the original school and the concrete frame construction. The image shows the kind of temporary improvements carried out prior to demolition, showing the Science and Maths block and the office and IT room at the rear.

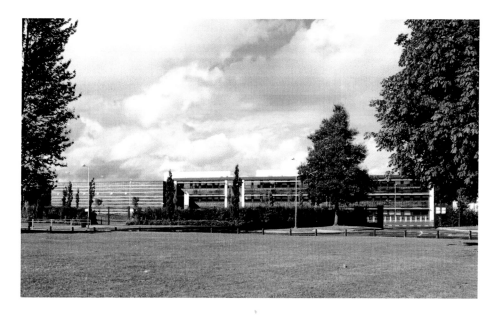

Academy

The year before Penrose left Harefield, he became involved with setting up the first school in the village, which was built on the site of the present church hall in the High Street. Because of his association with Harefield and with improvements in education, his name was chosen for the secondary school when it came to be built. It was 200 years after the departure of Penrose that the time came for the future of the school to be debated. The school built in 1954 had earned itself a reputation for failing standards and poor performances, which did not achieve the targets set by government. That was then reflected in falling roles and unsatisfactory achievements. The building had accumulated a number of add-ons over the four decades of its life, leading to poor maintenance, and with it the deterioration of building fabric. But whatever the failures of management, leadership and hard times for the staff, the old school nevertheless met with a fierce, vigorous and committed programme of demolition.

Harefield Academy

Since opening, student numbers have risen dramatically and the academy is now a real school of choice for local families. Facilities are excellent and this year (2013) it received government recognition for its improved standards. One of the unique features of this school was the addition in 2011 of a fifty-bed state boarding house named after Lord Adonis.

Harefield Academy

The Harefield Academy, designed and built by Aedas/Taylor Woodrow, replaced the John Penrose School in September 2005. The new academy caters for children between the ages of eleven and eighteen, with accommodation for 750 students aged eleven to sixteen and a further 250 post-sixteen students. The academy project was one of the first of a government initiative to improve opportunities and standards for young people. Four businessmen (who at the time were directors of Watford Football Club) worked with the (then) DfES to sponsor a new academy in Harefield with the aim of developing sporting excellence and high academic standards.

Harefield Academy
The academy is regarded as a government flagship, built to improve failing standards. The present retiring head teacher has provided the driving force and leadership necessary to achieve a remarkable turnaround.

The Village as a Community

The term 'community' is often applied to a wide range of individuals, but a range that nevertheless shares a common bond. Members need to be inclusive and feel safe within that community. Sometimes village communities have developed as though it was a natural process, and on other occasions they have been planned or purposely built.

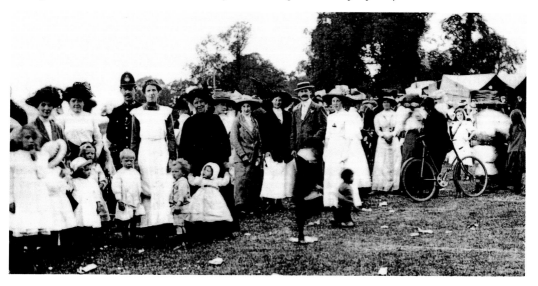

Community Celebration: Coronation, 1911, and Millennium, 2000

For the coronation of King George V on 22 June 1911, local celebrations began with a procession led by the Tower Hamlets Military Band to the church and then to the village green, where the Union Jack was raised. A feast of cold meats, cheeses, salads, plum pudding and cake was served to about 2,000 people. 120 gallons of ale and 100 gallons of beer were drunk. Each child received a medal, orange and a bag of sweets. The day that featured dancing and sports competitions for cash prizes concluded with a bonfire and fireworks. Whether events of this special character survive may depend on the availability of those keen enough to organise them.

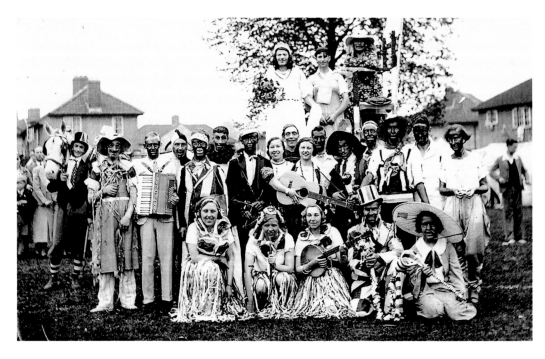

A Gathering Point

There were activities on the green, and a good many off it, where you met on the green but proceeded onto somewhere else. In most cases, the village green has acted as the focal point of an activity. Thus in March 2013, a crowd gathered on the green on Palm Sunday in the Christian calendar as a central, recognisable meeting place and walked (in this case with Mikey the donkey) downhill to St Mary's church. The intense cold of this winter's day (and lack of carrots) occasioned an early retreat by the mule.

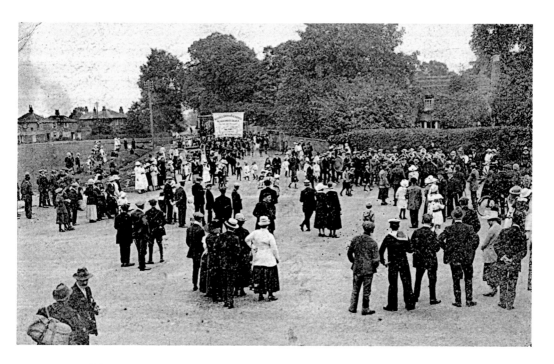

For Special Events

A small enough village like Harefield is well endowed with its fellowship groups, scouts and guides, bowls and choirs. These ensure community spirit is active and healthy. The Silver Jubilee on the green in 1977 is shown below. Similar 'special event' days brought residents out for the Queen's Silver Jubilee in 1977. The opening of the globe in the Millennium celebrations of the year 2000 acted as a similar magnetic attraction.

Trips to Enjoy

Communal activities in Harefield include an annual fête in July and a monthly magazine. The village green makes a significant difference to the village and how the way the place functions is perceived by others, especially a visiting outsider. These acts of village support and involvement have a history in themselves and residents went out on organised trips by coach or charabanc on many occasions.

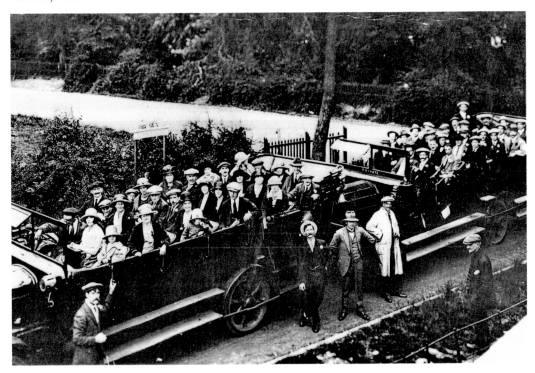

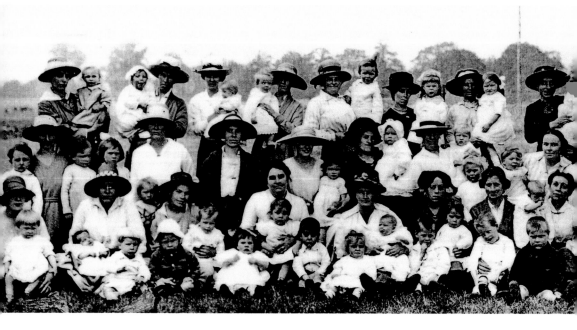

The Green as an Amenity

Other issues like poor transport have helped its special character survive. Sometimes, residents didn't want to go further than their own village green, as in Welfare Day 1920. With a green on their doorstep, there was no need to go further.

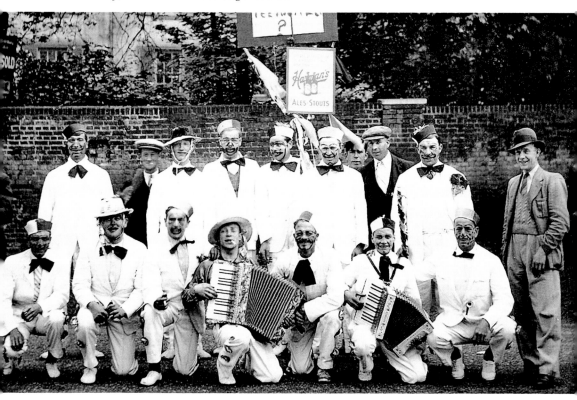

Being Good Neighbours

Over the years, community character has been enjoyed and recorded by many. It has its ups and downs, but its rough times can also be its strengths. Harefield has evolved over time and its occupants have acknowledged a common bond, which has been strengthened not only by the green but also by its bonds with another nation on the opposite side of the world.

In assessing the community role that open space and buildings can play, it follows that the green is there to be used and enjoyed, but it is not the only facility available to the public. A newly emerging organisation since 2005 has been the Harefield Academy. Here, pupils and staff still speak of the village and have seen their role as engaging with the wider community and encouraging links with other organisations. For them, that description of maintaining a village community is still very relevant.

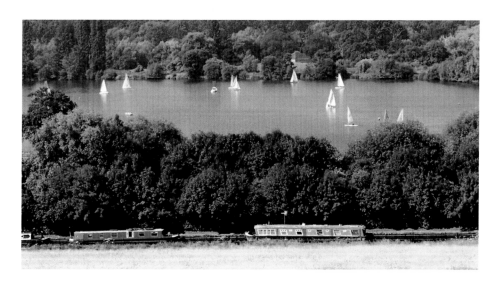

Observations: The Value of Village Life

To cover in some detail an area as extensive as this requires a clear strategy, especially when provision is being made to walk the streets as well. An indication of the length of each walk was given at the beginning to ensure the distances are within the walker's own capabilities. The intention has remained throughout to explain how Harefield has developed by giving an account of its history and describing the impact it has had on the lives of its inhabitants.

Throughout its recent history, Harefield has given a measured response to the tests of time and resisted the sort of inappropriate pressures for change with which we are all too familiar. Those pressures for potential housing sites, as well as upon the High Street frontage, can pose significant threats to the appearance and character of a village like Harefield. Acting together, many groups and teams have played their part in supporting village life. The roles to be grasped include those within schools, hospital, residents' associations, history societies and traders' groups, with communication and appreciation embracing all age groups. The old adage that those who sleep on their rights lose them is as true now with the prospect of high speed travel as it is defending open space from development.

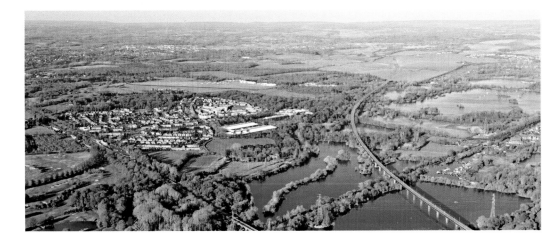

(*Image courtesy of HS2 Ltd*)

The residents of 1928 nearly got a very different environment in which to live. Can the increasing speed of decisions and access to jobs across the country justify the destruction of the countryside? How fine a balance needs to be struck with such an irreplaceable commodity? The above artist shows how a viaduct over the Colne might look, but are the benefits worth the sacrifice?

Visually, Harefield's centrepiece is its green, with a pond, a public house and domestic buildings set around it. Wherever residents go about their daily activities, the village green has always been there performing the role of a back drop. One public event after another, from the Coronation of 1911 to the celebration of Jubilee year in 2012, has had that location in common. The number of activities and events recorded here is but a small sample of those that have taken place in the history of Harefield as it continues to evolve over time.

Acknowledgements

British Library Newspapers; Royal London Hospital Archive and Museums Service; Colne Valley Regional Park, Visitors' Centre and Website; Ordnance Survey; *The Times* Newspaper; the *Harefield Gazette*; Local Studies, Archives & Museum Service, L. B. Hillingdon; Malcolm Barres-Baker; Eileen Bowlt; Victor Bristoll; E. D. Chambers; Alan Corner; Carolynne Cotton; Revd Martin Davies; Gini Dearden; Isa Dinler; Dennis F. Edwards; Jonathan Evans; Lynn Gadd; Wilfrid Goatman; Michael Gough; Russell Hallam; Doug Hiza; Victoria Hume; Duncan Lochhead; Jim Lofty; William Lofty; Terence Handley Macmath; Veronica Mortimer; Reg Neil; John Parkinson; John Ross; Michael Rumble; Mary P. Shepherd; John Spinks; Matthew Taylor; Geoffrey Tyack.